THE STREET

THE STREET
A JOURNEY INTO HOMELESSNESS

B.J. LACASSE

TCU
PRESS

FORT WORTH, TEXAS

Library of Congress Cataloging-in-Publication Data

Lacasse, B. J.
 The street : a journey into homelessness / B.J. Lacasse.
 p. cm.
 ISBN 978-0-87565-500-0 (alk. paper)
 1. Homelessness--Texas--Fort Worth--Pictorial works. I. Title.
 HV4506.F67L33 2012
 305.5'692097645315--dc23

 2012017268

TCU Press
P. O. Box 298300
Fort Worth, Texas 76129
817.257.7822
www.prs.tcu.edu

To order books: 1.800.826.8911

Designed by fusion29
www.fusion29.com

REMEMBERING

From the moment you are born, at your first gulp of air, you are somebody. Immediately you are someone's daughter or son. Maybe you are a brother or sister, a granddaughter or grandson, even a great-grandchild. When you die, you still are someone—an integral part of your family tree, a unique branch.

There are many homeless people who, at the time of their deaths, have no identification or known next-of-kin. In Tarrant County they are classified as "unknown," given a file number, cremated within seventy-two hours, and interred in a plot purchased through a program for the cremation and burial of paupers. I would like to pay homage to those unidentified individuals— including all the homeless who died before officials even began to keep records.

This book is dedicated to all those who passed away while living on the streets, especially to those I came to know. These lists below represent the homeless of Fort Worth who have died from the beginning of this project to the time of publication.

IN MEMORIAM 2010

James Allen Ayodele	John A. Cothrum	Roger Johnson	Linda Phillips
Antoine	Patsy Davis	Allen Karenzo	Raymond Polk
Donald R. Barney	Horace Dean	Katy Kemper	Louise Rabb
Glen W. Birdow	James Dysard	Nathaniel Lewis	Elizabeth Rabon
David Bodeker	Don Elizey	James Lister	Teresa St. Clair
Jimmy Brogdon	Troy Evans	Steven A. Moffat	Karen Shearhart
Veronica Brown	Cheri Ruth Fogal	Delores Moody	James Silcox
James Scott Butler, Jr.	Teeyana Hatley	Dan Mudheimen	Patricia Strand
James Butler	Earl Lee Howery	Louis Nathan	Carolyn Uehlinger
Solomon Cephas	June Jensen	Kenneth Perry	Derrell Whitfield

IN MEMORIAM 2011

Gary Ali	Howard Fryar	Linda Holland	Robert Kevin Polk
Willa R. Battles	Betty Green	Preston L. Hunt	James Rice
Richard Blair	Willie Green	Jay Hunter	Mary A. Rountree
Joe Don Brandon	David Griffin	Kenneth Johnson	Mildred J. Schrader
Manual Chavez	James Griswold	James LeMay	Joseph Simmons
Ralph Claunch	Karen Guffee	Dameron G. Love	Lina Jill Simmons
Jerry Cotton	Jerry Gulley	John Alvin Lovell	Linda Smith
William Covington	James Hale	Jo Beth Marchand	Kevin D. Taylor
Larry Dobbins	Ralph Hansen	Douglas Martin	Mike Templeton
Crawford Duffey	Johnny Hawthorne	Kathy McClendon	Henry Venious
Charles Emswiler	Tim Hischase	Donna Moore	Frank Vera
Pearline Ester	Raymond Hitchcock	Paul Ortiz	Cayla Walsh

IN MEMORIAM 2012

Sandra Brisbon
Hilary Eaton
Bobby Lawrence Hunt
Shareece Sheppard
Edward Turkal

THE BOOK IN YOUR HANDS JUST MIGHT CHANGE YOUR LIFE.

As we rush about our busy lives, we sometimes pretend that we do not see the man sleeping on the sidewalk or the frightened woman on the corner with two kids and all her worldly possessions. We turn away, rationalize, sometimes blame, and go on about our lives. Denial takes the pressure off our hearts, but it does not change the facts we encounter on the street.

Homelessness is misery. Heat. Cold. Rain. Snow. Bug bites. Constant uncertainty. Nothing is easy when you are homeless. Lack of shelter takes a toll on the human body and spirit. Like quicksand, it pulls people down toward despair and death.

It's no wonder we want to turn away.

The extraordinary feature of this book is that the images and reflections it contains invite and encourage us to engage people who are homeless rather than turn away. This book is going to introduce you to some extraordinary people: your neighbors.

B.J. Lacasse is a remarkable young photographer who set out to tell the story of her friend Johnny and those like him who make their beds on the streets of Fort Worth, Texas. The documentary project began as a commemoration of the twenty-fifth anniversary of the opening of the Presbyterian Night Shelter.

At the earliest shows, B.J. shared the excerpts from the journal she kept during shooting as an artist statement. Initial reaction was so positive to both the photographs and the journal entries that a traveling show soon began to take shape. Photographs and journal entries were mounted on cardboard boxes and *The Street* went on the road.

It did not take long for word to spread about the compelling and beautiful show. B.J. became a regular speaker at churches, community organizations, and schools. Visitors were invited to share their reflections on the show and attest to its power to open eyes and hearts, break down stereotypes, and urge people on to action.

Done poorly, intimate photographs can make you feel like an intruder in someone's life. The images in *The Street*, however, make you feel like the friend of a friend who has stopped by to see how things are going. The pictures in this collection convey the humanity of their subjects.

The world into which B.J. takes us may not be one that is familiar, but the people are accessible. The scenes and the stories they tell are tough, but the pictures reveal a level of trust between photographed and photographer that puts one at ease. Things may not be okay, but it is okay to be together. B.J. and I share a hope that this collection might stir you to action. Great progress has been made in Fort Worth at reducing the number of people who are homeless. That progress is the result of hundreds of volunteers, employers, landlords, neighborhoods, philanthropists, corporations, community groups, and individual donors chipping in to be part of the solution.

The end of this book provides some powerful images of the ways in which housing transforms lives. This hopeful note is important because it reminds us that progress is possible and that, together, we can accomplish much.

A great deal remains to be done in our work to ensure that there is a roof over every bed. Homelessness is intolerable and unnecessary. I hope that your life will be changed by getting to better know your neighbors—the people you meet in the street.

MAYOR MICHAEL J. MONCRIEF
September 2011

ACKNOWLEDGMENTS

I cannot begin to write a word for this book until I first express my heartfelt and overwhelming sense of gratitude to everyone along the way who made it happen. To all the brave and courageous people who let me photograph them and so willingly shared their stories with me: I love you all and hope that one day you will have a home and peace in your lives and hearts. To Janeen and Lyndsay: Thanks for asking me to help with your project. We have come a long way from the kitchen counter, brainstorming about a way to pull this off and help the people in the shelter. Thanks to all the very special people who work day in and day out at the shelters and other organizations that serve the homeless. You truly are lifesavers! Thank you, Debbie, Lee, and Roxanne for being living examples of kindness and compassion.

Thank you to all the churches that go way beyond the call of duty to help feed, clothe, and counsel the homeless. Thank you to the hundreds of volunteers who give so much, so often. Thank you to the individual donors who give what they can; every dollar helps. Thank you to all the businesses and foundations; without your financial commitments we would not have any shelters for the less fortunate. Thank you to the quilting ladies who make hundreds of quilts for the homeless, year after year. Thank you to Colin Jones for being my PowerPoint specialist and for caring so much. A special thank you to my extended family of dear friends who walked this journey with me, shedding as many tears as I have. Thank you to my family, especially my father. You are the greatest role model a daughter could ask for when it comes to giving from the heart. To my late grandmothers, thank you for teaching me the significance and power that a simple hug can convey.

The biggest thank you to Dan, Melinda, Kathy, and Diana at TCU Press for making my words make sense and the images look magnificent, and to Mark for opening the door. Most importantly, thank you to The Leo Potishman Foundation for underwriting the book: without you these voices would remain silent, these faces forgotten.

INTRODUCTION

Fort Worth, Texas: a city that is truly the shining star of the Lone Star State, a city that is projected to become one of the largest in the state, a city that is economically diverse and sound. One can travel in any direction and see new business developments, technology centers, museums, hospitals, stadiums, and schools. Yet in the shadows of these major accomplishments and shiny new buildings there lies an unseen human tragedy—homelessness. Fort Worth, like many cities, has an unprecedented number of citizens—often referred to as bums, hobos, winos, junkies, street people, or vagrants—who call the streets home. Those stereotypes, however, are far from the truth.

THERE ARE OVER 4,042 MEN, WOMEN, AND CHILDREN WHO SURVIVE DAY TO DAY ON THE STREETS OF FORT WORTH, AND THERE ARE 4,042 REASONS WHY THEY ARE THERE.

Their stories encompass the causes and effects of systemic failure, whether it is poor health care, lack of education, economic downturns, generational poverty, or a job market reduced by new technology. Our city and, in fact, the nation are at a crossroads. Do we choose to push forward at lightning speed, leaving millions of people adrift in the wake of advancement, or do we move forward with compassion and innovation to engage governments, businesses, philanthropy, and civic activism to meet the social challenges of the poor and disadvantaged? For too long it has been easy to look the other way and say "those" people choose to be there. If people knew that today's homeless include more mainstream citizens than ever before, most not too different from you and me, would it make a difference?

Homelessness is not restricted to one city. Homelessness does not discriminate by race, age, sex, or economic background. Homelessness is a national problem that deserves national attention and commitment to end it. As a nation we have the capacity to accomplish anything we put our minds to. This is America, after all. Ending homelessness does not mean more handouts to more people in need. The fact is that most homeless individuals would much rather receive a hand up than a handout. We must approach the problem with equal amounts of compassion and intelligence. We need to engage private-public partnerships to develop programs that actually encourage people to rebuild their lives, not programs that keep enabling the status quo. Manufacturers who can't fill their workforce because of a lack of skilled workers must find a way to educate people through apprenticeship programs. We need to challenge our universities to utilize their brightest minds to develop social enterprise models and get those models to the non-profits that need innovation. We need to encourage all organizations helping the homeless to share information so that services are not duplicated in the same geographical area. We need to hold accountable the organizations that receive the funds and hold the individuals receiving the benefits accountable as well.

What if a program provided free meals and administrators got the recipients to perform small tasks, like sweeping the sidewalk or helping in the kitchen? Wouldn't they begin to gain a sense of pride and self-worth? It may seem simple, but perhaps this is just the type of small step that it takes to turn a life around. Maybe we need to look at the "useless items" we throw away every day and consider that something headed for your dumpster could be a treasure to a shelter. There may be recyclable items that could be collected, turned into cash, and the funds donated to a local non-profit. Or better yet, look at the business model of TOMS Shoes. The whole company is based on a one-for-one idea of giving back. For every pair of shoes that is sold, one is given to someone in need. There are also a lot of initiatives that we, as individuals, can undertake at little or no cost.

Every one of us could become a mentor in life skills and job skills. Shared knowledge is a magical concept. A mentor could teach a youth to read, write, and understand basic math or teach a young man or woman how to use tools of a trade; everyone could lift one another. We could turn a subculture of self-loathing and dependence into proud, independent, and productive people.

To picture a world without homelessness is unrealistic. True, it will take generations to significantly reduce the numbers, but we have to start, so why not now? The best way to begin is to keep people from falling into homelessness in the first place. It is always easier to keep something from falling apart than to rebuild it once it has. To find the root of the cause you have to look at our education system. It is completely unacceptable for any child to leave school without being able to read, write, or add and subtract at the minimum. Not all children are cut out for college, so we at least owe them the education of a trade—any skill set to allow them the freedom to be financially independent. We must teach our youth about poor choices and their consequences. Illiteracy, dropping out of school, teen pregnancy, alcohol abuse, drug abuse, and criminal activity are all roadmaps that lead to homelessness. We as a society, as parents, as educators, and as mentors need to find creative ways to expose today's youth to organizations that serve people who make poor choices. We should teach them about social entrepreneurship, giving back, and paying it forward. If we can engage today's young people by making them a part of the solution, then we may be able to keep them from becoming another statistic, or worse. The street is not a place to call home for anyone. It is a harsh, cold, lonely, and dangerous place to be. Any homeless person will tell you that the street will eat you alive then spit you out for another day. We owe it to our brothers and sisters out there to do whatever we can to help: lift the ones we can and comfort the ones we can't. Even the smallest thing, like a smile, can change a life.

THE JOURNEY

My alarm sounded, breaking the silence of my room, bringing an end to a restless night. Today was the day!

The day I began my quest to use my camera and every ounce of photographic expertise I had to put a face to the homeless in the streets of my great city—Fort Worth, Texas.

I was so glad to have been asked to take on this project. It was an opportunity I had waited for, for nearly twenty-five years. My chance to fulfill a promise I made to a homeless man named Johnny, whom I befriended in 1984.

Raised in rural Pennsylvania, I moved to Fort Worth in 1984 and felt as if I'd moved to another planet. I was fascinated by city life, by Fort Worth's downtown, and would take my camera and walk the streets after work, documenting every nook and cranny of this new world. One day, while wandering around near the city hall area, I came across Johnny and a few other men sitting on a shaded park bench. I'd noticed them before, but this time I stopped to say hello. Johnny and his friends were my first introduction to the realities of homelessness. I visited them often during the next few months, listening to their tales of life on the street and stories of their lives before they fell. They shared photos of their children and grandchildren, and even of their lost wives and loved ones. I was bewildered: why were they here if they had family? It was only years later that I would learn about first and second and third chances, and bridges finally burned.

They gave me gifts on occasion—once a tube of Pillsbury biscuit dough that some passerby had given them to eat. What use could they make of it? They told me to take the biscuits home to bake. I wondered what kind of person would give raw bread dough to people living on the street. That's when Johnny pulled his hat off, made a face, and said, "You see, people are funny." Another gift I received from Johnny was a ballpoint pen from McDonald's. He handed it to me and said, "Maybe one day you will write about us."

A few days later I arrived at the bench to discover only one person sitting there. When I asked where Johnny was, the old man sadly replied, "He was picked up and taken to the tank." "The tank" turned out to be a place called the Fort Worth Rehabilitation Farm, run by Liberty Mission, founded in 1958, and located in an isolated field in what is now the Fort Worth Nature Center. It was a couple of days before I could get to the run-down old building—a place where the residents were definitely out of sight and out of mind. The grand plans for downtown Fort Worth were in their infancy in 1984, and drunks sleeping on doorsteps were not any part of that plan.

Inside the building I found several dozen homeless men sitting at picnic tables, feasting on baloney sandwiches and Kool-Aid. A staff member, puzzled by my visit, was pleasant enough, but she told me I'd just have to look around for Johnny—she didn't know anyone's name. Finally, I saw Johnny sitting at a table with his head down, looking frail, ill, and definitely suffering alcohol withdrawal. I sat down across from him, but Johnny no longer had a smile, a joke, or a story to share. That day, only sadness and pain came across the table. I drove away carrying some of that sadness and pain with me.

When I returned a few days later, they told me Johnny was dead.

I never returned to that place. The "Rehabilitation Farm" ceased operations later that year, on December 31, 1984.

I PROMISED TO TELL HIS STORY, THEIR STORY. THIS MISSION WAS FOR HIM AND ALL THOSE THAT LIVE LIFE ON THE STREETS TODAY.

OPPOSITE // **JOHNNY: "PEOPLE ARE FUNNY."**

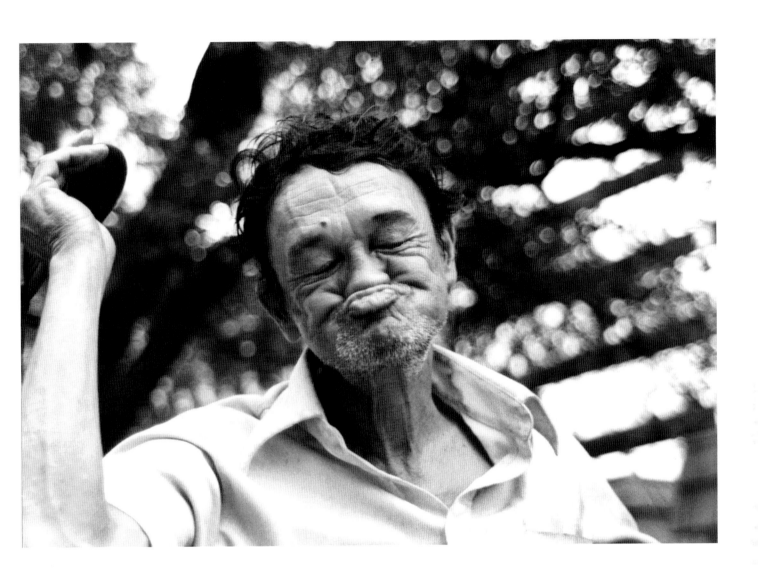

My truck seemed loud as the tires rolled onto the gravel road behind the shelter, ripping the stillness of that predawn moment. People lay sleeping all around. My heart was racing as my eyes and mind began to evaluate the scene that lay before me. I quietly retrieved my backpack from the back seat of my truck. It was fully loaded, carefully packed the previous night with all the essentials I thought I might need to win friends and gain favors. I was armed with toothbrushes, smokes, lighters, socks, gum, my notebook, pens, and as little camera gear as I could get by with.

I carefully pushed the door to my vehicle shut, trying not to make a sound. Slowly, my eyes adjusted to the lighting on the streets just before dawn. I spotted my first subject, a crippled man, in the glimmering overhead light just outside the main entrance to the Presbyterian Night Shelter. It had rained the night before and the concrete was still wet, except for a limited area protected by an overhang above the doorway.

HIS SMALL, ALMOST BOYISH BODY LAY STILL ON THE CONCRETE, NO BLANKET, NO PILLOW, NOTHING AT ALL, JUST HIS WALKER STANDING SENTRY OVER HIM AS HE SLEPT. ALL OF HIS WORLDLY POSSESSIONS WERE IN A HALF-FILLED PLASTIC GROCERY SACK TIED TO THE HANDLE OF HIS WALKER.

OPPOSITE // **MAN AT REST**

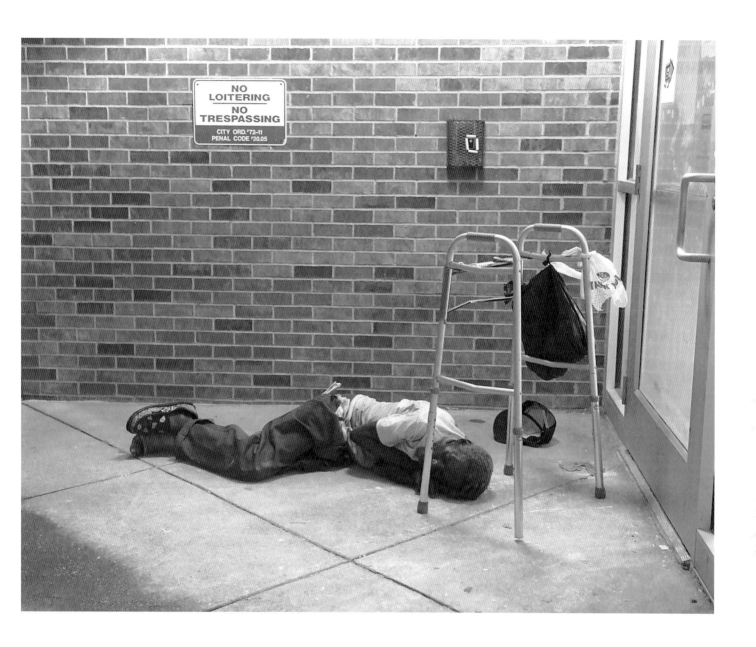

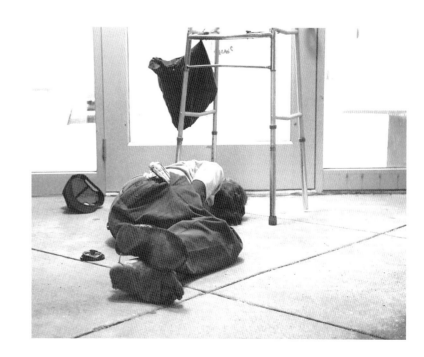

After quietly taking a few photos, I noticed the "No Loitering" sign glowing like a beacon above his body. I noted the irony. I thought about just how hard that concrete must feel to his frail skin-and-bones body. I moved slowly and quietly around him to capture the scene from all angles when I noticed one foot was covered with only a slipper, the other nothing but a very tattered ACE® bandage. A few more shots and it was time to move on. All the nervousness that filled my body was suddenly galvanized into a profound sense of urgency and responsibility for the assignment I was undertaking.

Before I took another step or photo, I prayed that God would walk with me every step of the way and come through my lens to capture the images that would make the most difference.

Daylight was coming on faster than I expected. I felt subtle movement all around me. What looked like piles of papers, cardboard boxes, trash bags, tarps, heaps of things began to take on human form.

I photographed bodies resting, lining the fence of the shelter grounds. People slept in cars, boxes, and on the bare sidewalk.

I SHOT COUPLES HUDDLED TOGETHER SLEEPING, ARMS WRAPPED AROUND EACH OTHER FOR LOVE AND FOR SAFETY.

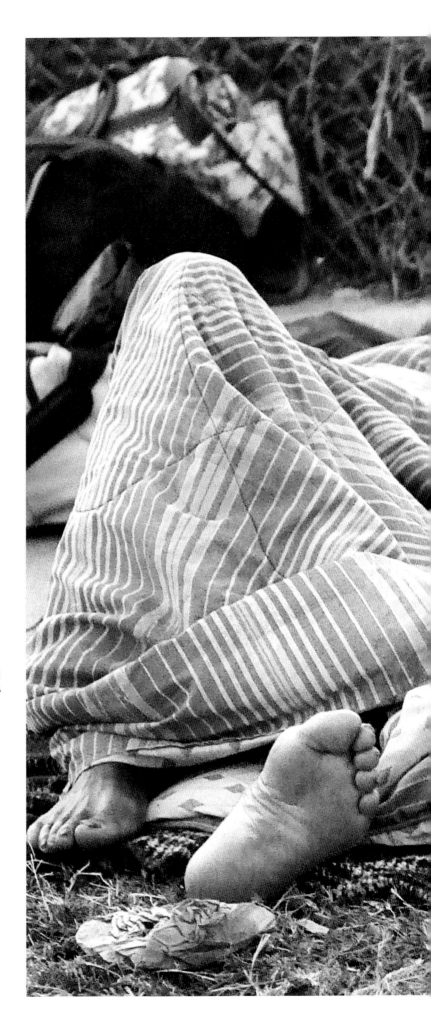

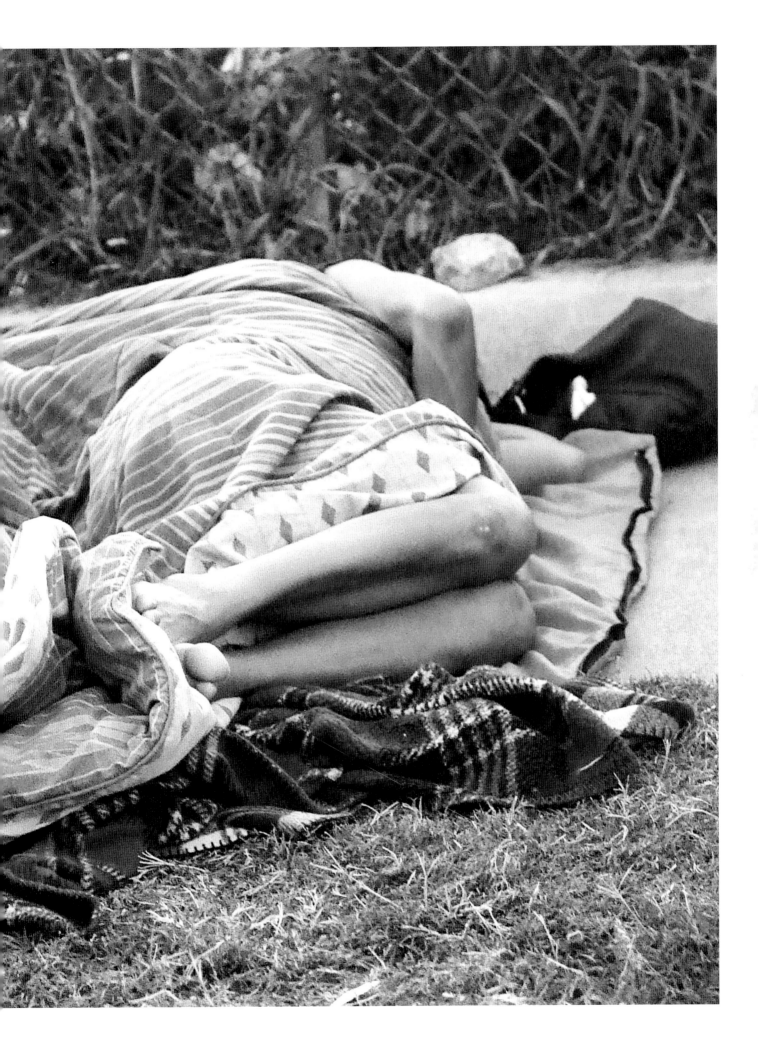

I NOTICED A YOUNG WOMAN ASLEEP IN A CAR WITH THE CONVERTIBLE TOP DOWN.

Finding a safe place to park was priority number one so that she could rest without worry, top down, in the suffocating Texas summer heat, when nighttime temperatures rarely dipped below ninety degrees. Her car was not just her means of transportation; it was also her home. The car was filled with all her belongings, only leaving room for her to rest, upright, behind the wheel.

RIGHT // **WOMAN SLEEPING**

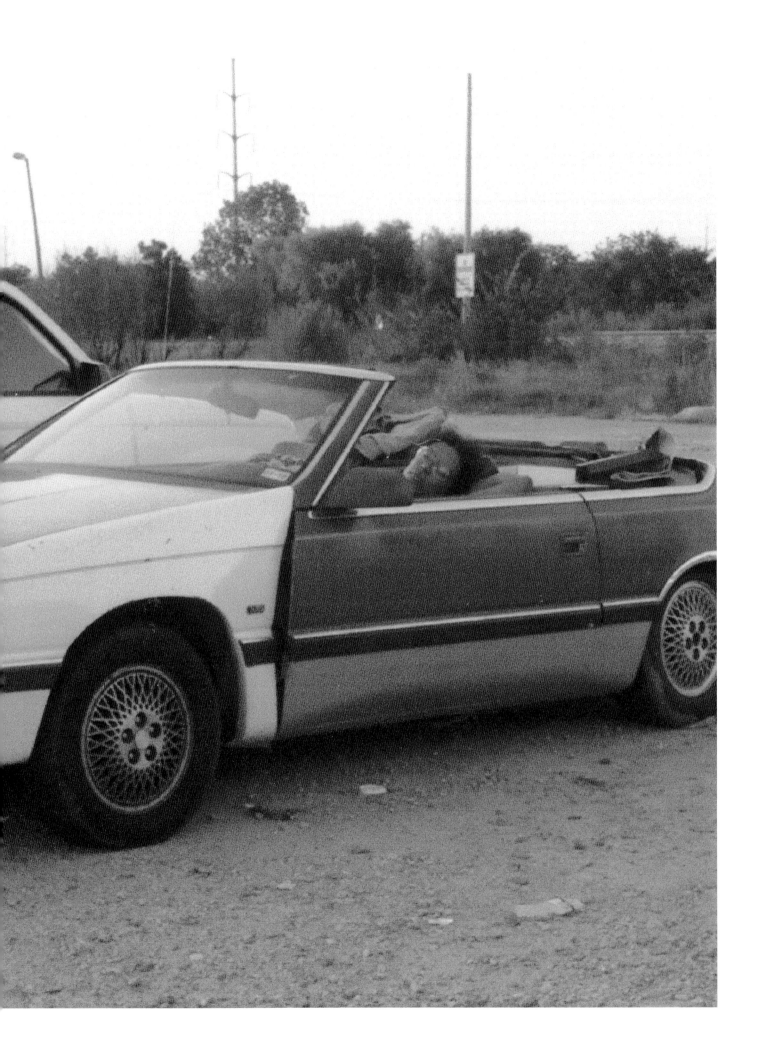

CYPRESS STREET (CONTINUED)

I photographed every nook and stoop that had life as I made my way down the street heading towards Lancaster Avenue, the main drag. That was when I stopped to document an older man fast asleep on a flattened cardboard box on the sidewalk. What made this person different from most was the fact that he was a double amputee. He had his wheelchair tipped over backward, his head pillowed on the seat back, to ensure it was not stolen while he slept. Sleeping bodies lay along the chainlink fence, along with trash the wind had deposited there. It occurred to me: when we pass unsightly litter, we notice it, think it is awful, and *someone* ought to do something about it; then the thought disintegrates as soon as the problem is out of sight.

The golden glow of the early morning sun as it barely broke the horizon was creating a movie set right before my eyes, except that this was not a stage set; it was real. The smell of urine and stale cigarettes filled the stagnant air. Papers, bottles, wrappers, food containers, soda cans— you name it—were everywhere, like some grand street festival had been held the previous night. In reality, they were the refuse left by hundreds of people who had to fend for themselves outside the night shelter's walls.

WHEN WEATHER CONDITIONS GET TO THE EXTREME ENDS OF THE TEMPERATURE SPECTRUM, THE SHELTERS REACH MAXIMUM CAPACITY— LEAVING ONLY THE GROUNDS CLOSE BY AS A SOMEWHAT SAFE PLACE TO GATHER FOR THE NIGHT.

OPPOSITE // **CHARLIE**

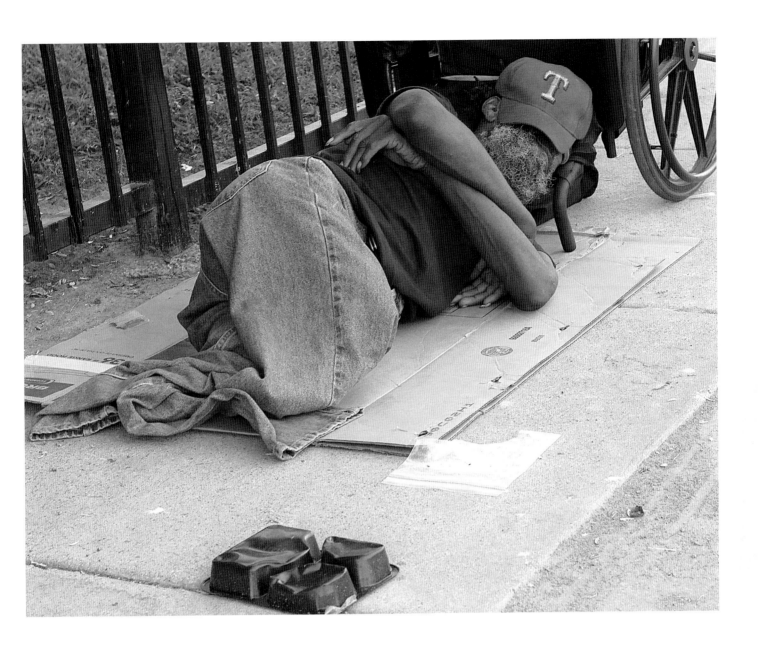

I made my way to the corner of Lancaster and Cypress Street looking left and right. I chose left. A man was sitting down right there at the corner, leaning against the wall, eating a donut and some chips. He greeted me with a cheerful good morning and asked me if I was new. He seemed nice enough, so I decided to sit down and set my plan into action. First was to win his trust, tell him why I was really out here, then ask if I could shoot his portrait and get some information about his life before and after he became homeless.

After he agreed, I learned his name was Don, age fifty-two, born in Fort Worth, Texas. He served fifteen years in the US Army as a Buck Sergeant and an S4 in charge of supply control. His tour had taken him to California and as far away as Germany. After losing his job as a paperhanger, he was left homeless. No, he did not put up wallpaper. I asked. He hung those annoying door hangers on people's homes for eight years. Now he does landscaping when the opportunity arises, and landscape companies drive through town looking for day laborers. He is a religious man, Southern Baptist, and attends church every Sunday. When I asked him what keeps him going in life, he told me that you have to always think positive, don't give up, and don't listen to others who think they know what they are talking about. Most times they are wrong, he declared, and will lead you down the wrong path. We talked for a short while longer, both of us saying cheerful hellos to others passing by. I photographed him with ease. It was like shooting photos of an old friend I'd known all my life. We shook hands, said God bless, and I moved on to capture more faces and stories.

I photographed daybreak on the streets. With each second that passed more people emerged and lined the street corners. Nearly an hour had passed as I walked and talked to more homeless men and women milling around before heading to their usual spots for the day, seeking shelter from the sun.

Time on the streets seemed to be the hardest thing to keep track of, and I felt it, that sense of timelessness. Night becomes day then day becomes night, over and over and over again, utter survival the only agenda. The heat was almost unbearable already: it was not even 7:15 and the temperature was already pushing into the mid-90s. The forecast for the day called for the thermometer to reach a blistering 102 with a heat index of 110.

I CAME ACROSS SEVERAL TALKERS, BUT NO TAKERS ON THE PHOTO END OF THE DEAL. ALMOST ALL DECLINED BECAUSE THEY HAD SONS, DAUGHTERS, AND EVEN GRANDCHILDREN WHO DID NOT KNOW THE SITUATION THEY WERE IN. WITH A HEAVY HEART I HEADED BACK DOWN CYPRESS TO THE MAIN SHELTER.

OPPOSITE // **DON**

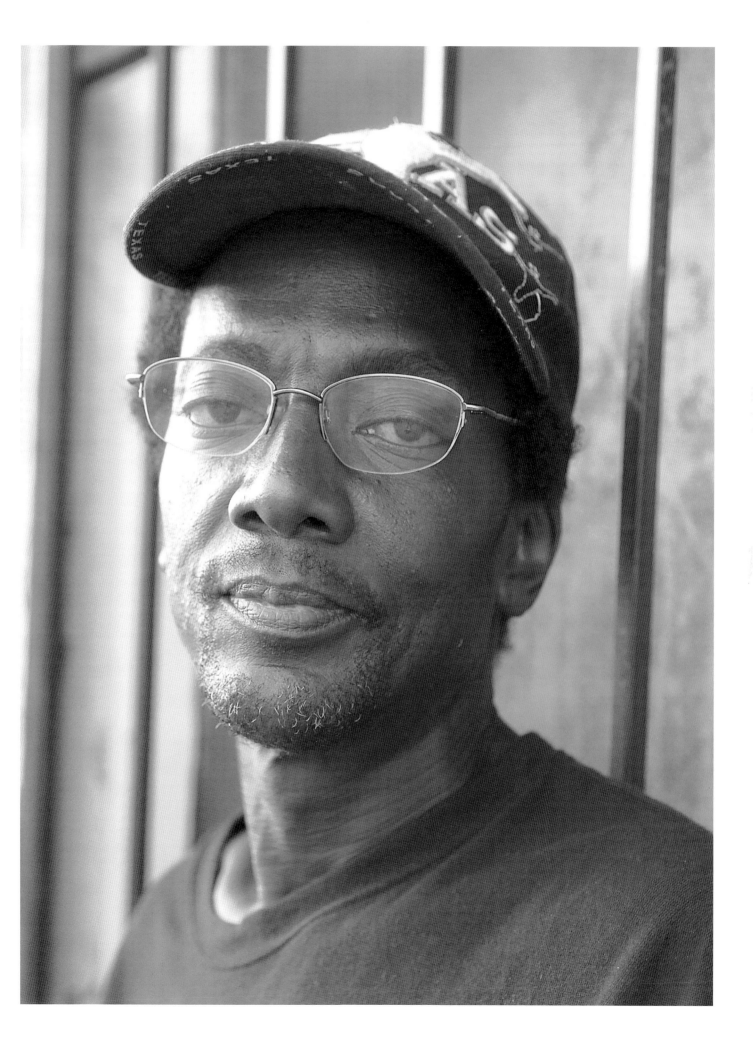

I had walked only a couple of blocks down the crumbling sidewalk when I struck gold. A beautiful woman and her two little children were waiting for the daycare bus. She was kind, that much I knew at first glance. We talked, and I shot images of all of them together, then just the babies. I wanted to pull heartstrings, and I found a symphony. I got my notebook out and began to write her story. The mother was Trinina, age thirty-one. The beautiful baby girl with larger-than-life eyes, the eyes of an old soul, was Trenyce, who was only eight months old. Marcus was a typical three-year-old boy, full of fire and curiosity when it came to the camera. Trinina's story was as heartbreaking as any that I knew of, but, unfortunately it is one that you hear more and more often on the evening news. The family relocated to Fort Worth from Atlanta, Georgia, to begin a new life with her husband's grand new job. The family sold everything but the car and a very scaled down amount of personal effects to relocate to their new apartment. Unfortunately, there was no happy ending to the story. The economy continued to worsen, and her husband's new job fell through, leaving them in a strange city with no friends, no family, no support; and the likelihood of this young black man finding an immediate job was virtually nonexistent. It didn't take long until they went through all the funds they had and were forced to sell the famliy car, which compounded his already difficult job search, all to buy a little more time in their apartment. Eventually, the inevitable happened: the family ended up homeless. They made their way to the Presbyterian Night Shelter, but the story gets worse. PNS, like almost all shelters, houses women with children in a separate building to best protect their clients. The young mother and her two babies were housed in one building, while the dad was sheltered in a different facility. Even though the building was only a few hundred yards away, to him it might as well have been a few hundred miles as he struggled to pass the long, lonely, and chaotic nights away from his wife and kids. He began harboring feelings of total failure and became so depressed that he tried to commit suicide. He failed and was put in RESPY, a mental health recovery center, leaving Trinina alone with their two children.

One would never know of her difficult circumstances from her calm and loving demeanor. She was well-kept, very proud, and great with her kids. I asked her what kept her strong. Her answer was quick and simple, "The Lord." She also added, "Never give up hope." Every day, as the kids headed off to a few hours of daycare, she actively looked for work in customer service, a job she had held before.

During my time volunteering at the shelter, I discovered that many people find it incredible that babies are on the streets. Many have asked me, "Why doesn't CPS step in and do something?" The answer is simple. The women with children are homeless but not bad mothers. They love their children dearly, and most hope that their children are too young to remember this time in their lives. The majority of women with children who are sheltered have come to escape abusive situations in their homes.

Every bit of that early morning silence was now completely gone. The streets were abuzz in all directions with people talking about any events that had occurred overnight, men bantering back and forth, business owners driving by looking for cheap labor, and the usual chatter that takes place every day along the sidewalks. The shelters now harbored the peculiar silence that the street held just a few hours prior, as the mandatory 7:00 a.m. emptying-out was completed. I walked back to Lancaster, following the masses, and took back the corner spot I had occupied earlier in the day. I wanted to observe for awhile. Morning rush hour was in full swing now, and the roar of the passing cars seemed ominous as drivers seemed even more ruthless and uncaring than they had a short time earlier. Some drivers even gassed it as the homeless tried to cross the busy street, much like a cruel teenage boy might do if he spotted a helpless animal crossing the path ahead. Sweat beads ran down the back of my neck, and even my knees were sweating. I took photos from eye level while sitting on the brick-oven-hot sidewalk as this other world began to reveal itself and unfolded around me minute by minute. As the sun continued to climb, I began to realize that my mouth was already parched and the pungent air was getting distinctly worse. A wave of nausea swept over me. *Good God*, I thought to myself, *I have to walk or something*. I rose and headed west on Lancaster, away from the searing sun.

ONCE I STARTED MOVING I REALIZED IT WASN'T THE UNFORGETTABLE ODOR OR THE UNFORGIVING TEMPERATURE THAT WAS MAKING ME FEEL QUEASY. I WAS SICK AT HEART.

OPPOSITE // **TRENYCE**

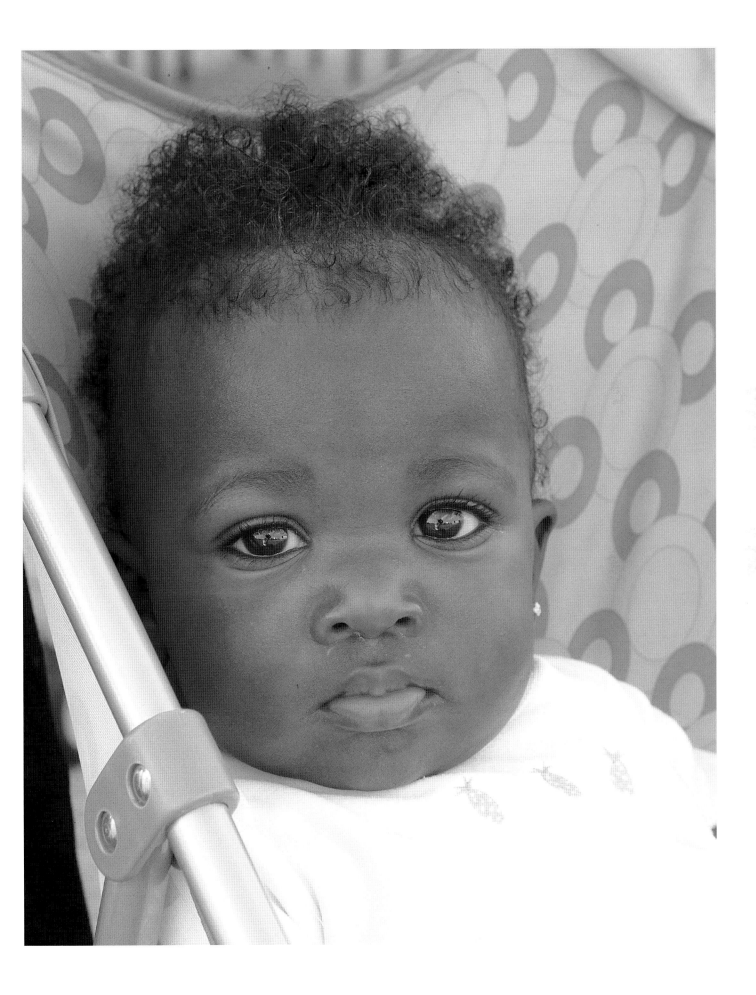

As I rounded the corner of a building down the street I met John, a well dressed fifty-seven-year-old man, gray-haired, clean-cut, and wearing a baseball cap. He was reading a book in the shade, against the wall of an abandoned building across from the Union Gospel Mission. He probably thought I was crazy as I introduced myself, explaining that I was volunteering my time as a photographer seeking people willing to let me photograph them and write down their stories for a traveling exhibit to benefit the Night Shelter. All the while I was dripping sweat and reeling from my journey so far. John was kind and chivalrous, standing up while offering me a seat and waiting for me to sit down. Our conversation came with ease and in such a flurry that I could hardly keep up with my notes. He was born in Oklahoma, attended Northeastern A&M College studying criminal justice, but graduated with a sociology degree. His last job, which he held for fifteen years, was for Central Parking in Dallas. He was very well trusted and collected the money from parking lots before losing this long-term job due to attrition. Jobs didn't come; funds dried up; and he became homeless. Because he did not know the ins and outs of street life, he fell victim to dehydration and malnutrition after a very short time of living on the street. Once he found his way to the shelter, he received meals and a safe place to sleep at night, although it took him almost two years to recover physically.

For John, living in a shelter made finding work difficult—as did his age. In addition to these challenges, John also lost his driver's license due to serious glaucoma in one eye, and because of the harsh conditions of street life, his health was still precarious. Wrapping up our visit, I asked what keeps him motivated day in and day out. He replied, "My strong upbringing." He believes in a good work ethic, has a strong Christian faith, and firmly believes that everyone should earn his or her keep. He has been homeless on the streets of Fort Worth since January 2006.

I almost lost track of time talking with John. It was nearly 9:00 a.m., and I was late meeting up with my prearranged guide, who was going to take me deep into the "unsheltered" world of the homeless. I made my way back to Cypress Street and to the main entrance of the Presbyterian Night Shelter. The director of operations at the shelter met me with a very worried smile, stating, "I've been looking for you. Mike is ready, are you?" I eagerly said yes, wondering to myself if I truly was. He briefly introduced me to Mike, and then we were off.

Mike, an Apache Indian from San Fernando, California, was going to be my new best friend. We shook hands and I thanked him for what he was doing for the shelter and for me. As we headed out I explained to him my goals: to meet people and get stories and photos that would show the unknown side of homelessness from their perspective. Mike was an easygoing man, soft spoken, and, most importantly, on my side. I could tell in just a few minutes that he was going to protect me from harm, since he was already looking around and using extra caution as we crossed the busy streets. We talked and walked deep into the underbelly of the city like two school kids taking the long way home from school. We were traveling to the encampments. The photojournalist side of me was exuberant over this opportunity to visit these places. Once there, however, I realized how naive and unprepared I was for the experience. Mike told me the places we were going existed only because they had not yet been discovered and destroyed by the police. Either that or the authorities were simply too afraid to go there. There are a large number of homeless that choose to remain unsheltered, setting up camps in the wooded areas around the city. Their reasons range from poor health, disabilities, and privacy issues to trying to keep their families from being separated. I promised Mike that I would never reveal the true location of any camp he took me to. I would never want to jeopardize any camp or its residents.

JOHN DID NOT WANT TO DEPEND ON THE SYSTEM TO TAKE CARE OF HIM. HE WANTED TO BECOME INDEPENDENT AGAIN AND WAS ACTIVELY SEEKING EMPLOYMENT.

OPPOSITE // **JOHN**

The first encampment we visited was one with no known name. It was well-hidden in a thicket of brush and overgrowth, under and in between freeways and over-passes adjacent to the city. Upon entering the trees and waist-deep poison ivy, my arms immediately became black with mos-quitoes. The words "press onward" echoed in my head as we went through poison ivy, briar bushes, and tons of broken glass. About thirty or forty yards deep, I began to see the first signs of human habitation.

IT WAS APPALLING, HEARTBREAKING, AND, TO ME, JUST NOT POSSIBLE IN THE USA, LET ALONE IN MY GREAT CITY. I TWIRLED IN CIRCLES TRYING TO PHOTOGRAPH EVERYTHING I COULD AS WE CONTINUED MOVING IN DEEPER.

RIGHT // **CAMP #1**

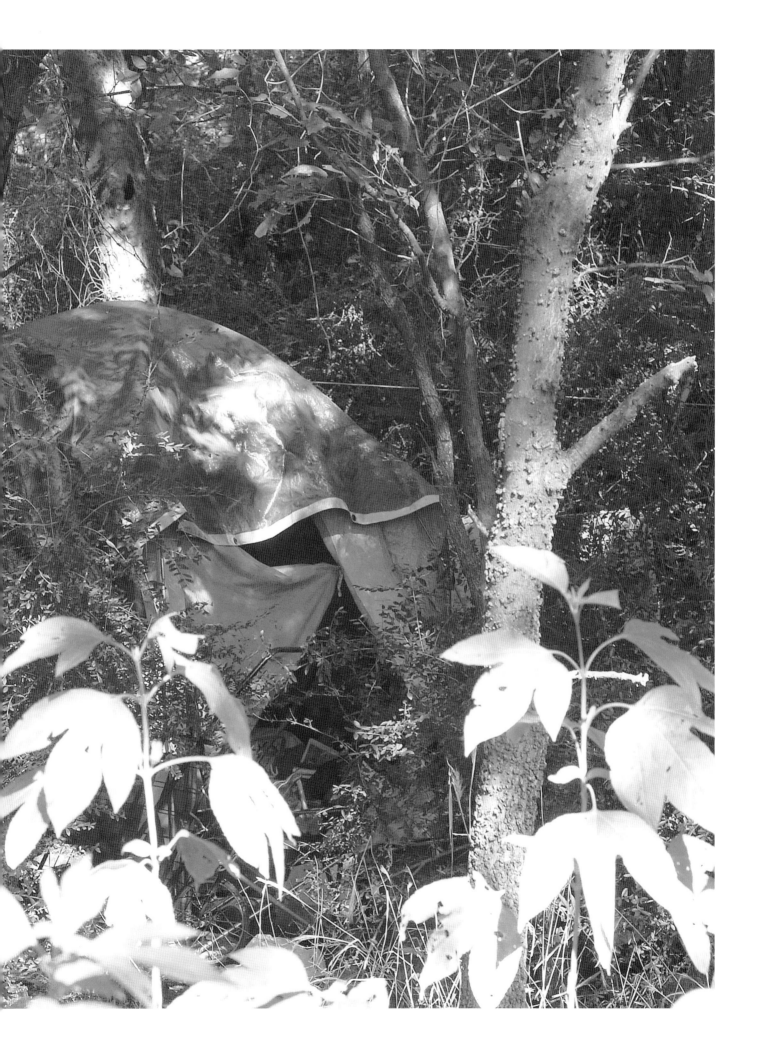

We called out, "Hello," to Anna—tent-dweller number one—and asked for a visit. She wanted nothing to do with us, shouting out that it was a bad time. We didn't press the issue and politely let her be. After moving up a few embankments, we located more and more tents and makeshift shelters. The whole place was unnerving, to say the least. Mike called out as I photographed, so as not to startle anyone, but the the rest of the camp was completely silent and empty. We were being eaten alive by mosquitoes and the smell was abhorrent. As Mike and I made our way down the hillside to an opening, I saw Anna sitting and writing in her journal, and I asked Mike if we could give her one more try. I felt I could not leave without capturing the human factor in this hellhole. I made my approach slowly and spoke to her kindly. I told her I was trying to help the homeless by telling the real story of their plight, and I hoped to bring about awareness and change. I said I just wanted to photograph her camp, her surroundings, the place she called home. She agreed. I spoke to her while I captured the filthy scene before me.

THREE LARGE ROCKS COVERED BY AN OLD RACK FROM A GRILL FORMED A MAKESHIFT STOVE; THAT, PLUS A BEAT-UP FRYING PAN WITH NO HANDLE AND GROUND LITTERED WITH TRASH, WAS ANNA'S KITCHEN.

OPPOSITE // **ANNA'S KITCHEN**

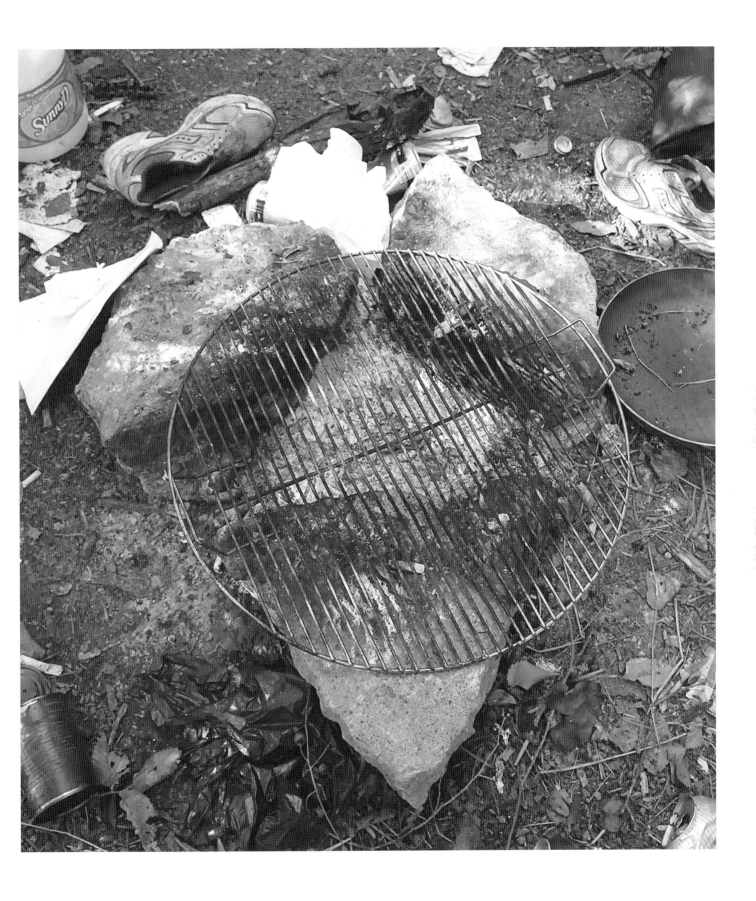

Studying Anna's kitchen made me realize we should all be aware of the things we take for granted every day. When we are hungry we go to the kitchen pantry or refrigerator and gaze at all of the many choices of good food we have to eat. More often than not, we decide we can't find what we really want, so we go out to eat or order something special that is delivered to our homes. Every day, without thinkng about it, we all act as if filled pantries and refrigerators are the norm, never realizing our blessings.

I offered up a pack of smokes when I noticed she was struggling to light a very small cigarette butt. Unknowingly, I had turned the whole situation to my advantage. She let me photograph at will. I was moving very cautiously around her camp, shooting, when all of a sudden she shouted out, "Be careful!" I didn't realize she was watching me so closely because she never looked up from her writing. She pointed by nodding her head back, letting me know to look behind me. I quickly spun around and looked down, realizing I was one backward step away from a latrine. Immediately the hair stood straight up on my arms and I shuddered in disbelief. Without even thinking I called back, "Whoa, holy crap! Thanks!" No pun intended. Before I left I gave her all the money I had, three dollars. I was saving it for just the right time, and now was that time. She smiled, graciously accepting the dollars, but never gave me her story. Maybe next visit, if there was one.

Mike and I left, heading on to the next encampment. As we walked he filled me in a little on why some people did not want to stay at the shelters.

HE SAID SOME FELT UNCOMFORTABLE BECAUSE THEY WERE DISABLED AND PREFERRED TO OPERATE ON THEIR OWN TIME SCHEDULE AND HAVE MORE PRIVACY. WE WALKED AND WALKED, OVER AND UNDER MORE BRIDGES.

OPPOSITE // **ANNA**

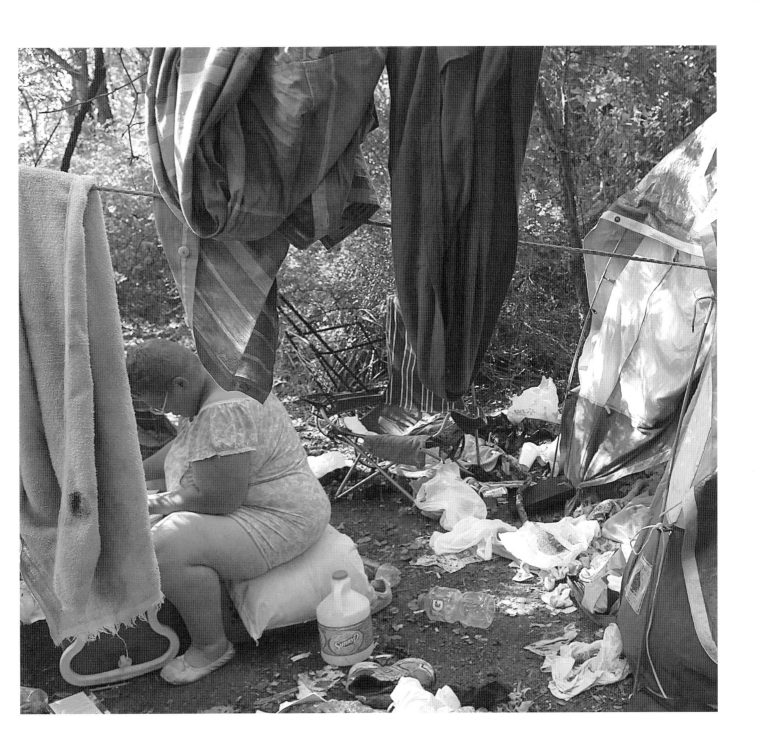

I learned more and more about camp life, the communal behavior, and the many rules of order that were in place. Each camp operated much like a little town, and every dweller had his or her own area. No one outside the camp was permitted to enter, visit, or stay unless permission was granted by all members. Population was controlled, so the size and number of people would not make the camp vulnerable and subject to discovery. If one dweller moved out, his or her area was usually sold to the highest bidder waiting to join that camp. Payment was either made in dollars or in trade of possessions. Each person had his or her own place and individual responsibilities, but there were shared areas and shared tasks as well. Some camps worked together to pool resources, survival knowledge, food, and money as a team, but others were the complete opposite. The people shared no bond and no friendships; they were only close in terms of proximity.

By now the sun was high and the heat was full on, unbearable and dizzying. We were both wet with sweat, our clothes soaked, and we were covered in scratches and bites. When I asked Mike how he knew where the camps were, he said he knew most of the folks living there. He also taught me how to hunt for signs of people living in the woods. Much like looking for animals in the wild, you follow the trails: small foot trails shimmering in broken glass.

ONCE I SAW THEM, IT WAS EASY FOR MY NEWLY TRAINED EYES TO RECOGNIZE THEM ACROSS THE LANDSCAPE, AND I WONDERED JUST HOW MANY LOST SOULS TRAVELED ON THESE SMALL FOOTPATHS BEFORE ME.

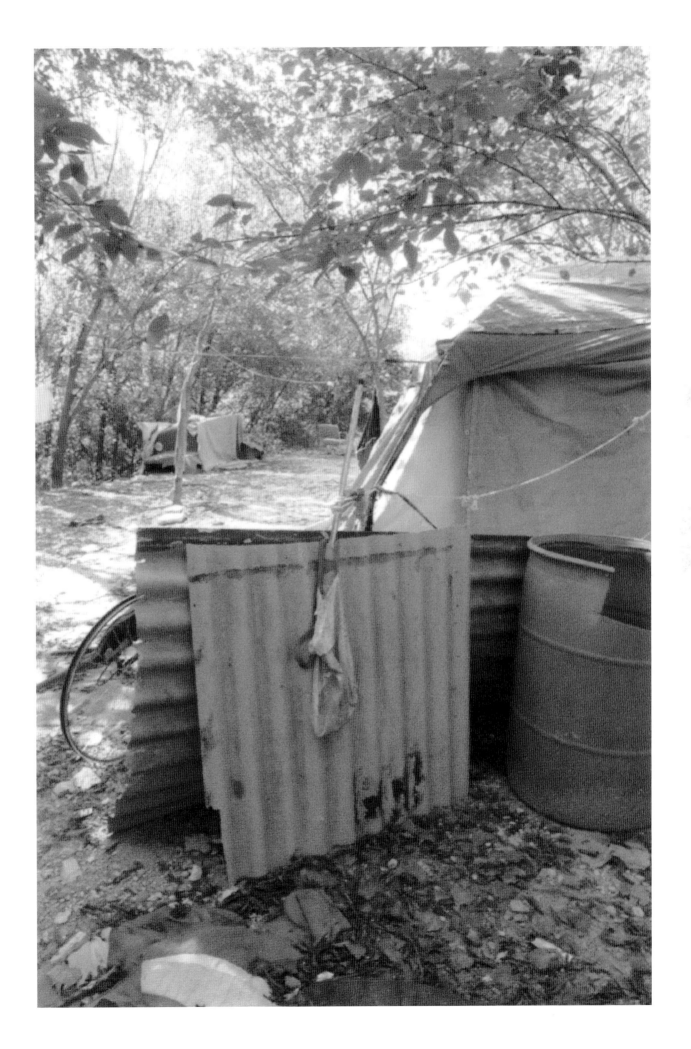

THE NEXT CAMP WAS CALLED THE RANCH. THIS CAMP WAS DEEP DOWN A STEEP RAVINE WITH A SMALL STREAM OF WATER TRICKLING AT THE BASE. WHEN WE REACHED THE BOTTOM, I NOTICED A BUCKET OF WATER WITH A BAR OF SOAP AND A BATH TOWEL BESIDE IT ON THE ROCKS.

Looking around I could tell that, with any amount of rain, the runoff and flash flooding would be deadly for anyone lying close to the bottom. The bedding areas were all up on various levels of the hillside, much like Native American cliff dwellers. There was no electricity, no clean running water, and no sanitation. Imagine spending your life coping with these issues, as well as the elements of nature, while living in a tent or makeshift home constructed with found objects. When it is bitter cold or brutally hot, when it is violently storming or rains for days on end, my mind goes to that place, and what I imagine breaks my heart.

Much to my disappointment, this camp was empty, too, but Mike was not surprised. He told me that most of the people come out early so as not to be seen leaving, which would expose their home to the police. We moved from one level to the next, passing by campsites, fire pits, and clotheslines strung from tree to tree.

Then we came upon a larger campsite. This one had a big fire pit with rocks for sitting around it—and *toys*. I looked around and spotted a Big Wheel, baby dolls, a few rain-ruined childrens' books that had been tossed aside, and two matted and soaked stuffed animals, no longer cuddly and fun. As we walked, Mike told me nonchalantly that nighttime would be a good time to come back and meet people. The thought of being there at night without light to maneuver through the brush, over rocky hillsides and rugged terrain, and through a camp full of people I could hear but not see was a thought I could hardly bear. I turned my focus back to my job and shot plenty of images to document The Ranch before we headed out.

After a steep climb out and a long walk beyond that, Mike and I sat in the shade by the railroad tracks and decided it was time for the water I had brought for each of us. We'd have to ration it; I had room to pack only one bottle apiece. I thought this would be a good time to photograph Mike and get his story.

OPPOSITE // **THE RANCH**

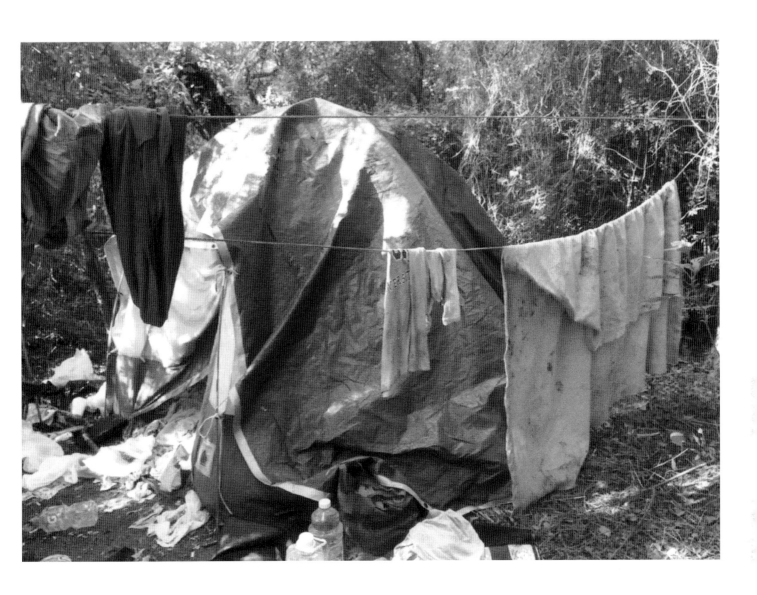

Mike, age forty-three, was born in San Fernando, California. He spent eighteen years working at a movie studio in security and as a bodyguard, and was even in background scenes in both Wayne's World movies. He moved to Fort Worth so his wife could be close to her children, but he later fell ill and lost everything, including his wife. According to Mike, she could not handle the shelter life. His health kept him from putting in a full hard day's work, but he told me that he liked to work. Now he lived and worked at the Presbyterian Night Shelter and was content to give back by doing what he could. He liked to make things easier for people. He helped at the door and at evening meal time; got the sick, the old, and the disabled to their mats at night; and cared for others all day long.

After we talked more and began to walk back to the shelter area, he confessed that he had leukemia and refused treatment.

The doctors told him he had maybe a year. He proudly said, "My one year was four days ago." I had a huge lump in my throat and tears welled up in my eyes as I asked why he chose not to go through treatment. He said there was no place at the shelter to be sick like chemo makes you. Knowing the living arrangements at most shelters, I understood completely. I told him I would probably have chosen to do the same if I were terminal. Why spend your last days sicker than you already are? Most days he did well with just some weakness and pain; overall his spirit was undaunted. He told me that only a few knew the truth, because he didn't want to be a downer for others around him. My heart cried out for healing to come to my new friend as we made our way to street level.

AFTER WE TALKED MORE AND BEGAN TO WALK BACK TO THE SHELTER AREA, HE CONFESSED THAT HE HAD LEUKEMIA AND REFUSED TREATMENT.

OPPOSITE // **MIKE**

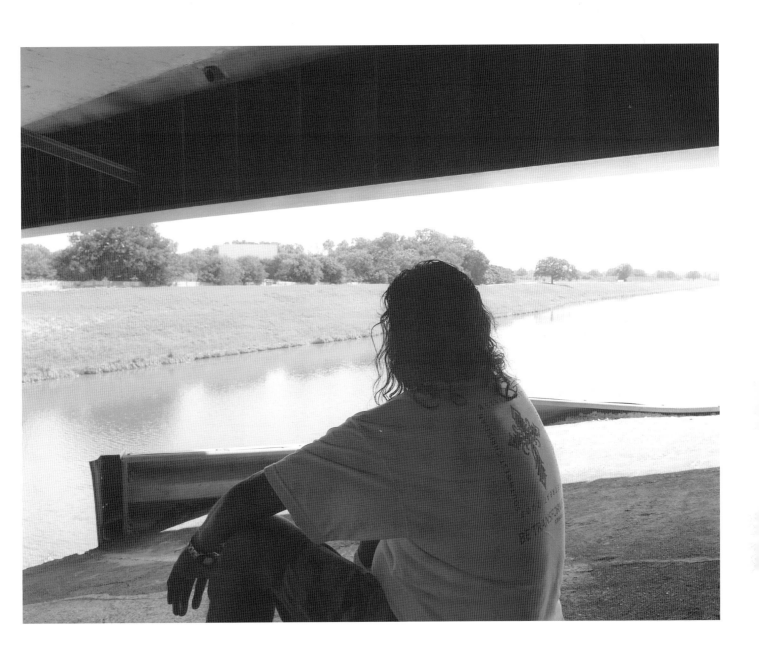

We were walking up a steep hill when I spotted a woman slowly making her way ahead of us. It was Anna, cleaned up and nicely dressed for the day. I almost didn't recognize her. Mike and I moved at a much faster pace, so we quickly caught up to her and said hello. As we passed by she called out, "Hey, you asked me what I needed awhile ago. I need school supplies. Paper, pens, highlighters, folders, you know, stuff like that." Her list was long and specific and I wondered if she had children. Then I remembered that when we first approached her at her camp she was writing in her journal. I figured the supplies were for her and told her I'd get the things she requested and bring them back tomorrow. I was pleased she was finding the ability to trust me, because I really wanted to know more about her and, for some reason, I felt as though we were kindred spirits.

The hundred-degree temperature was like a furnace with the heat bouncing off the blacktop. It made the conditions I witnessed seem even more suggestive of what hell might be like: unrelenting heat and so many lost souls. We were now back to Cypress Street. I told Mike thanks and that I would meet him at 7:00 a.m. tomorrow. As we parted ways, I felt more comfortable being back in familar territory. I spent the next few hours hanging around the night shelter on Cypress Street. I can honestly say that, at this point, I felt more like one of them than I did my old self. It was weird how I was already adjusting to the sights, smells, sounds, and the general chaos of the streets.

THE HUNDRED-DEGREE TEMPERATURE WAS LIKE A FURNACE WITH THE HEAT BOUNCING OFF THE BLACKTOP.

RIGHT // **STREET LEVEL**

30

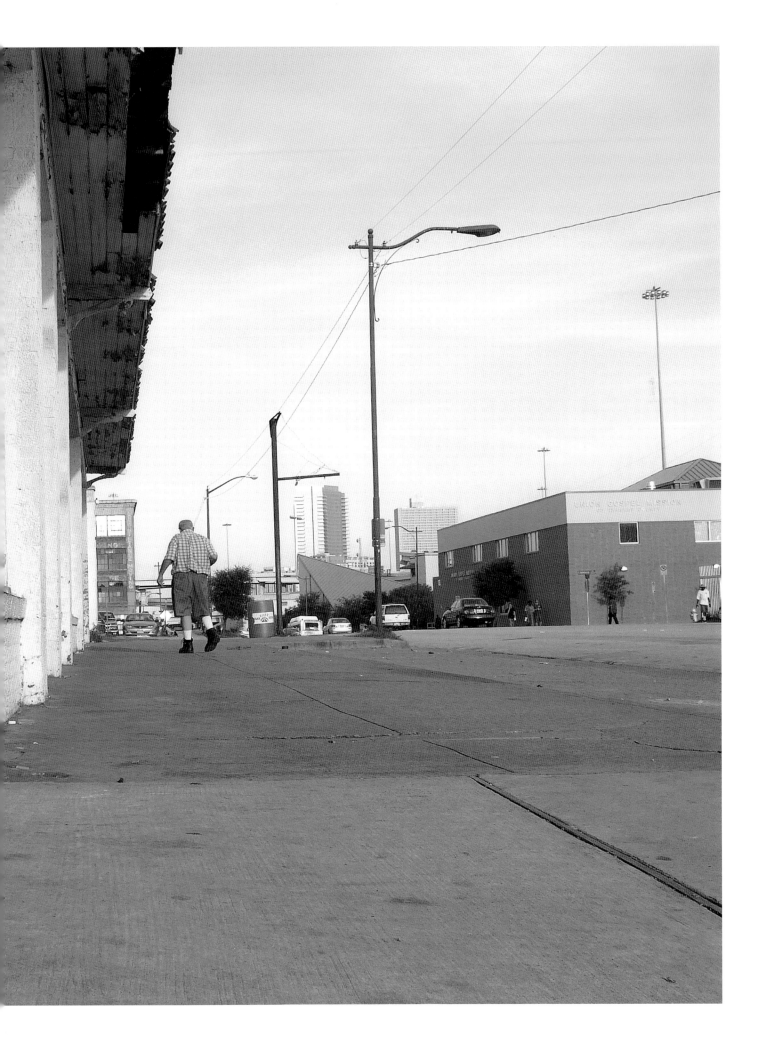

I met J.C. "Chicken" Hawkins who was born in Plato, Oklahoma, in 1924. He moved to Fort Worth in 1934 to milk cows and ride horses. Now he lives at the Friendship House and considers himself a treasure hunter; the treasures being those things he finds on the streets every day. He was so kind and gentle he could have been anyone's granddad. He's the type of guy you just want to sit with for hours, sipping a sweet tea and listening to the countless life stories he would be eager and delighted to share.

Through the lens of my camera I saw an old man who worked hard his whole life, never complained, and always saw the good in any situation he faced. I wondered why he was here on the street and homeless at eighty-five years old.

Then it came to me: all the hard work he did day in and day out, throughout his life, was done from the position of "a hand" or the help. He never received a paycheck that provided social security benefits in his later years, and he did not have a pension plan. Chicken probably worked until he was used up, spent, too old, and too weak to do enough chores to be paid, and he was more than likely let go as a result. I am sure in his mind that was "just the way it was" for folks like him, and he seemed happy and content.

I was just finishng up my interview with Chicken when Amber, a night shelter client I had met a year or so earlier, came up to say hello and find out what I was up to. I told her all about what I was doing for the shelter and asked her if she wanted to walk with me for a while and maybe introduce me to some of her friends. She was very outgoing and was more than happy to have some company.

THROUGH THE LENS OF MY CAMERA I SAW AN OLD MAN WHO WORKED HARD HIS WHOLE LIFE, NEVER COMPLAINED, AND ALWAYS SAW THE GOOD IN ANY SITUATION HE FACED. I WONDERED WHY HE WAS HERE ON THE STREET AND HOMELESS AT EIGHTY-FIVE YEARS OLD.

OPPOSITE // **J.C. "CHICKEN"**

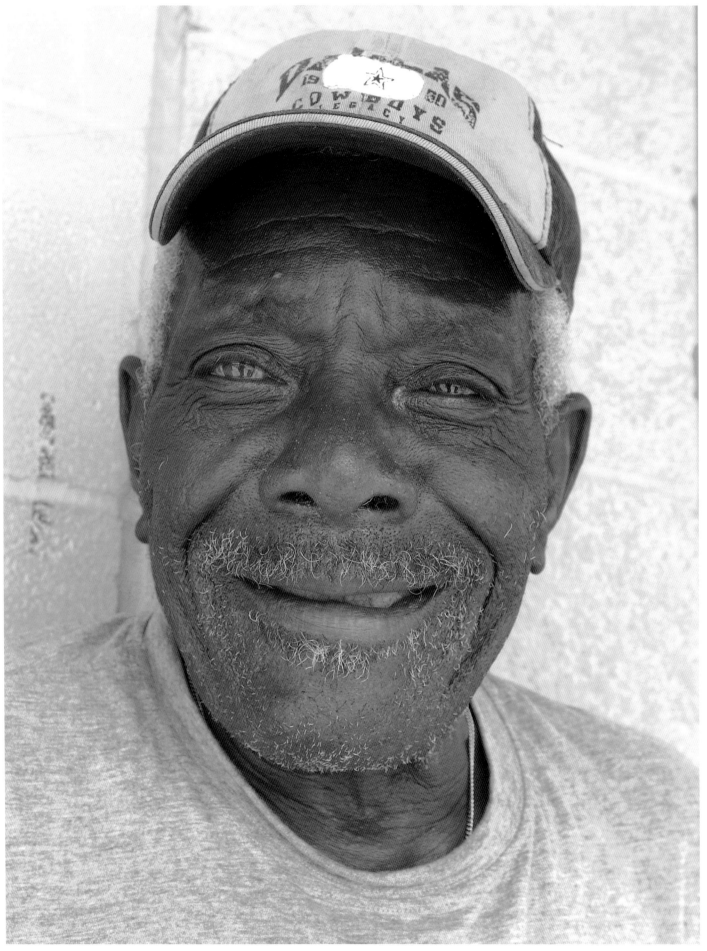

We had walked just a short way when we came upon a group of girls sitting on the curb. Amber introduced me to Sherry, Mary Ann, and Tamarah after we both sat down with the group. It felt darn good to finally sit down. Amber immediately began telling everyone about me, how we met, and then about the project. Thanks to Amber's introduction, the girls and I had an instant rapport, and they were all in for photos and storytelling. I photographed them as a group and then individually. Sherry was picking a sticker off her sock when she said, "Damn, I thought I had it bad. Look at your socks! You're covered in stickers and scratches. You look just like one of us!" I had no idea that my socks were now brown, rather than white, and covered with stickers. All of them burst out laughing and I couldn't help but join in. That's when I felt an uncanny camaraderie building. We all sat around having a few more laughs at my expense when I decided it was time to break out the goodies I had stashed in my backpack. I pulled out smokes, gum, socks, lighters, razors, and dental kits with toothbrushes. They went wild, each grabbing up her favorite thing first. I had made sure there was enough for everyone to get one of everything. That is when, in an instant, everything changed. Mary Ann held the new toothbrush in her hand tightly as tears began to flow down her dirty cheeks. There was a long moment of silence as I gazed back at her, holding my breath and thinking, I must have done something wrong. Finally, still gripping the toothbrush, she said, "B.J., I never thought a day would come in my life that I would be so thankful for the gift of a toothbrush." Tears filled my eyes, too. I reached out to her and touched her shoulder to tell her it would be okay, although deep down inside, I did not know if that was true. The group became more somber and the tone of the conversation became more serious.

I SAT WITH THESE WOMEN FOR SOME TIME, TALKING AND LISTENING. THEY BEGAN TO OPEN UP, TELLING ME THE STORY OF THEIR LIVES ON THE STREETS.

OPPOSITE // **AMBER'S GROUP**

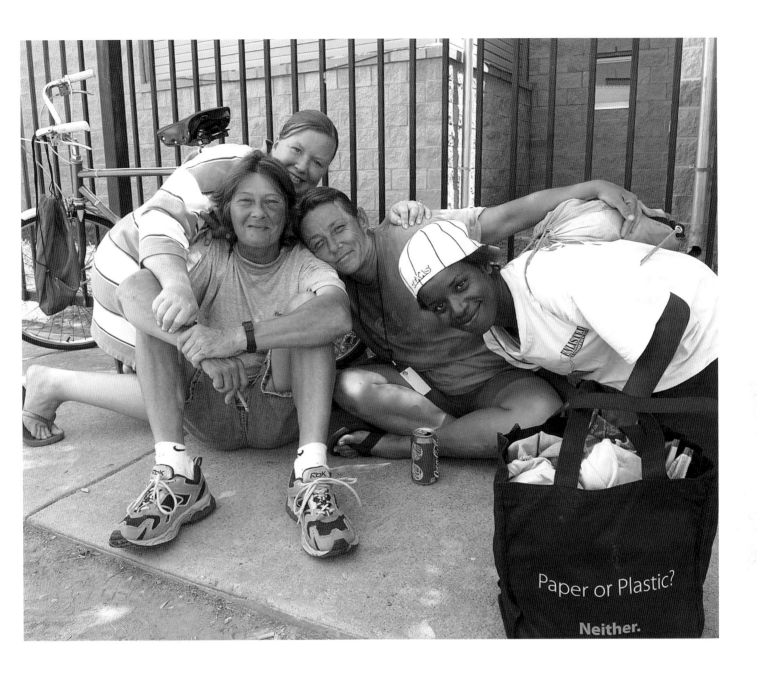

Tamarah was born on November 12, 1981, and was Fort Worth born and raised. She didn't offer up much more information after I took her portrait, just a big smile before she moved on down the filthy sidewalk, leaving just the three of us visiting. Mary Ann and I had a lengthy and very candid conversation while sitting together on the curb on that sweltering summer day. She told me, "If you are a woman and new to the streets, you better become somebody's girl quick, or you would soon be everyone's girl, if you know what I mean." Mary Ann was born in Dallas, Texas, on June 15, 1967. She began to tear up as she told me how her life was: facials, manicures, a nice home, a happy family, and a couple of Cadillacs parked in the garage. She was a bookkeeper and payroll manager for Service King but lost everything due to drug use. She explained how she was arrested late one night while making a quick run to the store for some smokes. She was pulled over for a minor moving violation, but the officer noticed something in her purse as she went for her license and arrested her for possession with the intent to sell because of the amount of drugs she was carrying. Mary Ann was later convicted and sent to jail for felony possession. While she was in jail, her husband divorced her, and her family no longer had anything to do with her. Everyone she knew abandoned her from that point forward. She had two kids, one twenty-two and one twelve; both were currently living with her brother. After spending hard time in prison, she couldn't get work or housing. She had been stabbed seventeen times and shot once. She told me she was clinging to her last bit of hope. I could tell that, at one time, she was a beautiful woman, but now her body was covered in scars, insect bites, and other telltale signs of street life. Before we parted ways she said, "I sure hope your project works and people listen to you. You may be our only hope, because ain't nobody gonna listen to us out here."

She said everyone she knew was dead and everyone who knew her treated her as if she were.

Mary Ann's name is on the list of those who died on the streets in 2011.

SHE SAID EVERYONE SHE KNEW WAS DEAD AND EVERYONE WHO KNEW HER TREATED HER AS IF SHE WERE.

OPPOSITE // **MARY ANN**

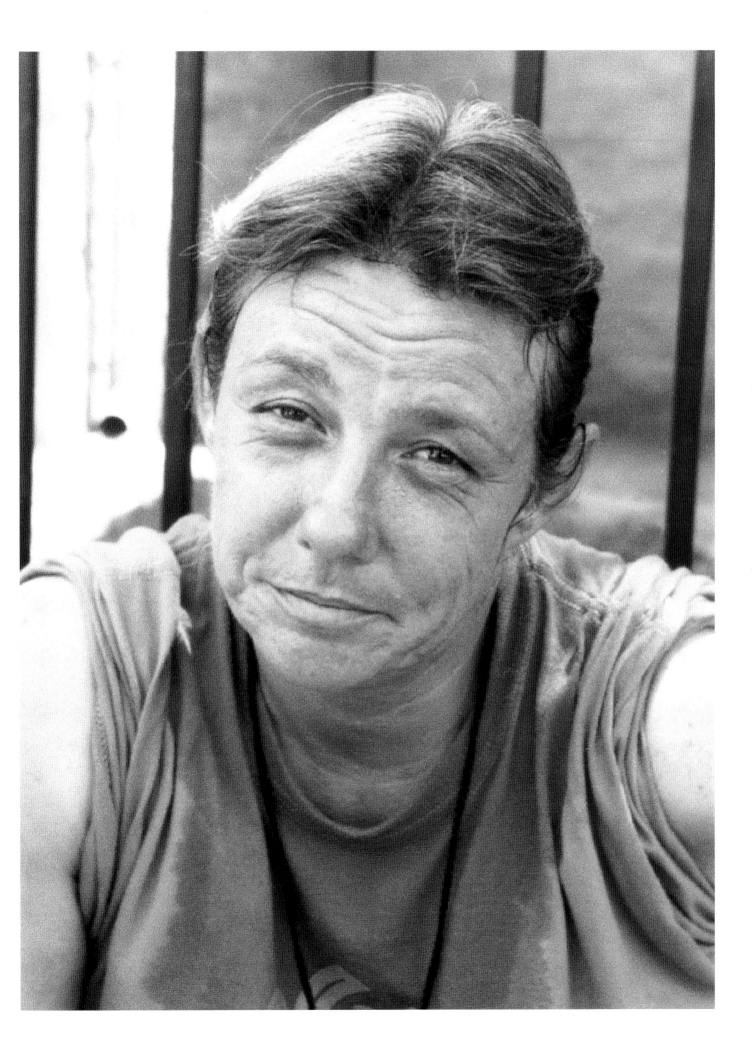

Sherry was born on April 3, 1961, in Arkansas, and moved to Fort Worth thirty years ago. She sat back and took a long puff of the cigarrette I gave her and then pointed to her face. Her left cheek was red, swollen, and on its way to becoming very black and blue, a clear example of how dangerous life on the street is for a woman. She said that last night she "had the crap beat out of me" for a bus pass and her last six dollars. It was scary how quickly bad things could happen, and how they could come out of nowhere. We talked more about her life and family, but I could tell she was beginning to get sad and was slowly shutting down. Sherry said she ended up homeless as a result of a bad relationship and nowhere else to go. Life was not kind to her through the years. She had bad teeth, a telltale sign of many years of drug abuse, and I figured that played a part in her downfall. When I asked her what kept her going every day she stated, "Knowing that it is not always going to be like this. Things will get better somehow; they just have to."

It was midafternoon, but I felt like I had been out here for days. The heat was oppressive and, after the girls' interviews, my heart was so heavy I was ready to call it a day and save some strength for the following days. I also wanted to bathe, get a cold drink, and, most of all, be home. I went to my truck, took my pack off, and jumped in to drive away. That was when it hit me:

could drive away. I sat there unable to move or even turn the key in the ignition. My hands were trembling and tears began streaming down my face. I dropped my head and prayed to God that what I was doing here would make a difference.

The drive home seemed ten times longer than usual. I stared at my house, in my nice westside neighborhood, as I pulled in and stopped at the bottom of the driveway. For the first time in my life, I saw my house with changed eyes and realized just how blessed I was.

I walked in, dropped my pack, went straight to the laundry room, stripped off all my clothes in front of the washer, and started it. I couldn't get into a hot bath fast enough. I wanted the sweaty street dirt off of me and the cuts cleaned. I wanted the bites to stop stinging. As I bathed, scrubbing till my skin felt raw, my thoughts raced back to the street. I thought about the women who asked for razors and the ones living in the woods without running water. I was physically and emotionally exhausted, but I had put in only a little more than half a day. I felt like I had failed in my mission. Now, my goal was to put in a full day, to really see what it was like from dawn until dusk on the street. I immediately began preparing for the next day. I had to download images, recharge batteries, reload my backpack with goodies, and

make a trip to the office supply store to find everything on Anna's list. It was just about evening when I realized that, since I'd been home, I had been unable to sit down. I paced about the house as my mind tried to process every little detail of the day. There was only one way to find peace and decompress: write it all down. I sat down at my laptop, read through my notes from the day, and reviewed all the images I shot. My fingers could hardly keep up with the flood of words and emotions that engulfed my mind.

I WENT TO MY TRUCK, TOOK MY PACK OFF, AND JUMPED IN TO DRIVE AWAY. THAT WAS WHEN IT HIT ME: I *COULD* DRIVE AWAY.

OPPOSITE // **SHERRY**

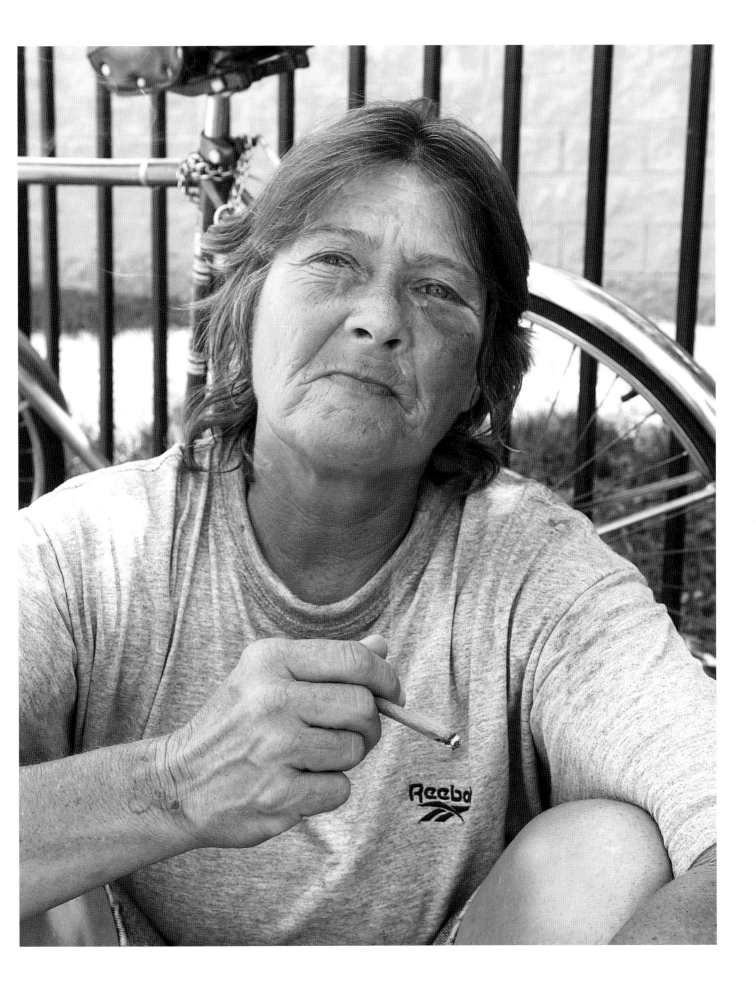

Once again my alarm clock shattered the silence of a short, restless night. Upon waking I realized I had lost that feeling of anticipation and eagerness I had yesterday. Today was different. I knew what to expect, which made getting started more difficult than I ever could have imagined. I was still physically and mentally exhausted from the previous day. My legs were sore; I had bruises I didn't know were there before; and I was sunburned, but the thought of meeting up with Anna and giving her the supplies she wanted made my petty troubles disappear. If being out there one day made me feel like this, I couldn't begin to imagine how being out there for years must feel.

I left the house with my backpack once again loaded with gifts of gratitude for their willingness to share and the necessities they needed so desperately. The time was 5:30 a.m., a little earlier than the day before, because I now knew life on the streets began before daybreak. Today I was more determined than ever to get the images that would tell the truth—the very sad truth—of the harsh life on the streets. The sun was not yet breaching the horizon as I pulled in to park. The overnight temperature did not go below 89 degrees, and it was once again expected to reach a daytime high of at least 102 with a heat index of 110 to 115 degrees.

NOW THAT I REALLY KNEW WHAT TO EXPECT, IT TOOK ALL MY WILL TO MAKE MY WAY BACK DOWN CYPRESS STREET.

RIGHT // **SUNRISE**

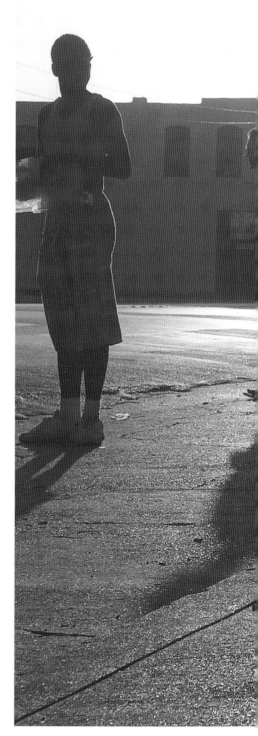

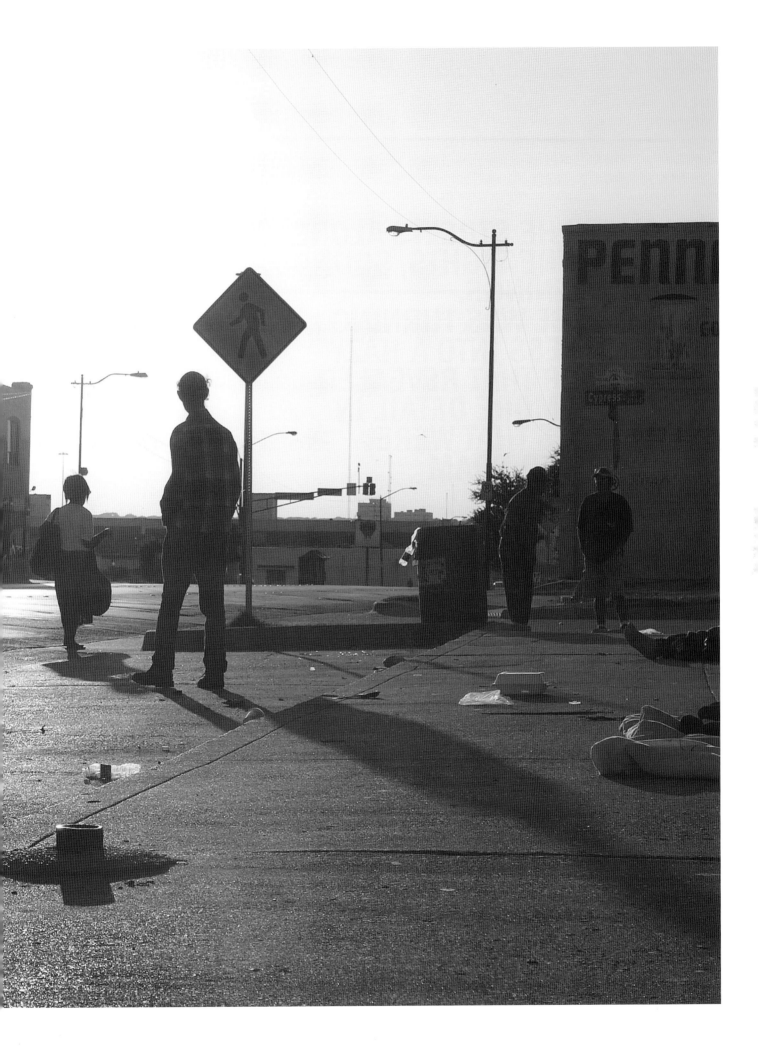

Once again the air was pungent with the smell of urine and stale cigarettes. The odor had become familiar to me; like a place I knew from my past, like when you smell something that makes you feel like you just walked into your grandmother's house, but what I was smelling had a completely different connotation.

I ROAMED THE STREETS ALONE TAKING IN THE SIGHTS, SOUNDS, AND AWAKENINGS. THE SUNRISE WAS TURNING THE DARKNESS INTO A HAZY BLUE COLOR THAT REVEALED MORE AND MORE DETAIL IN THE FIGURES THAT WERE BEGINNING TO ROAM THE STREETS.

OPPOSITE // **DAYBREAK ON THE STREET**

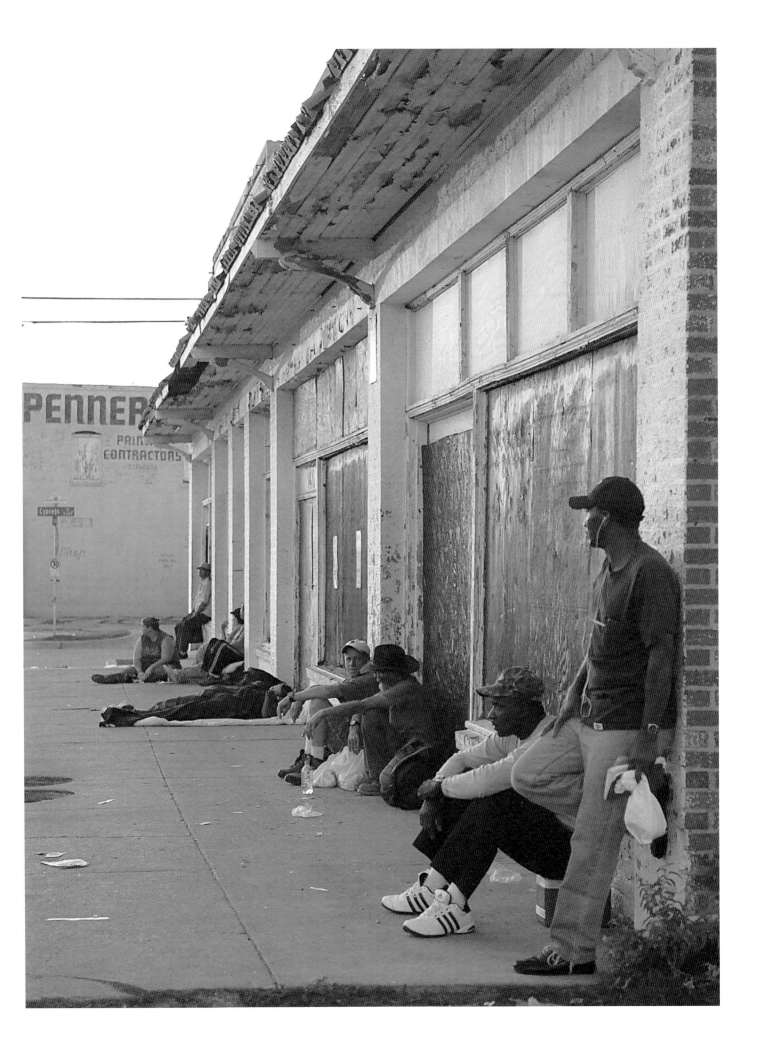

My first human contact was a woman named Sondra, born in Fort Worth, Texas, on March 18, 1956, at John Peter Smith (JPS) hospital—the county hospital that serves many of the very poor. She did not finish high school, but found work first as a volunteer at JPS and later as a paid employee in the rehab unit. She did not tell me about her decline into homelessness. She had been on the streets for four or five years, which I am sure felt like a lifetime to her.

Sondra became disabled after being struck by a car while crossing the street in May of 2006.

After spending a long time in the hospital and rehab, she returned to the street. She now has a brace on her leg and walks with a limp, but she always has the biggest welcoming smile on her face. A large wooden cross swings from her neck as a testament to her unwavering faith in the Lord. We roamed around a bit before she introduced me to Richard.

SONDRA BECAME DISABLED AFTER BEING STRUCK BY A CAR WHILE CROSSING THE STREET IN MAY OF 2006.

OPPOSITE // **SONDRA**

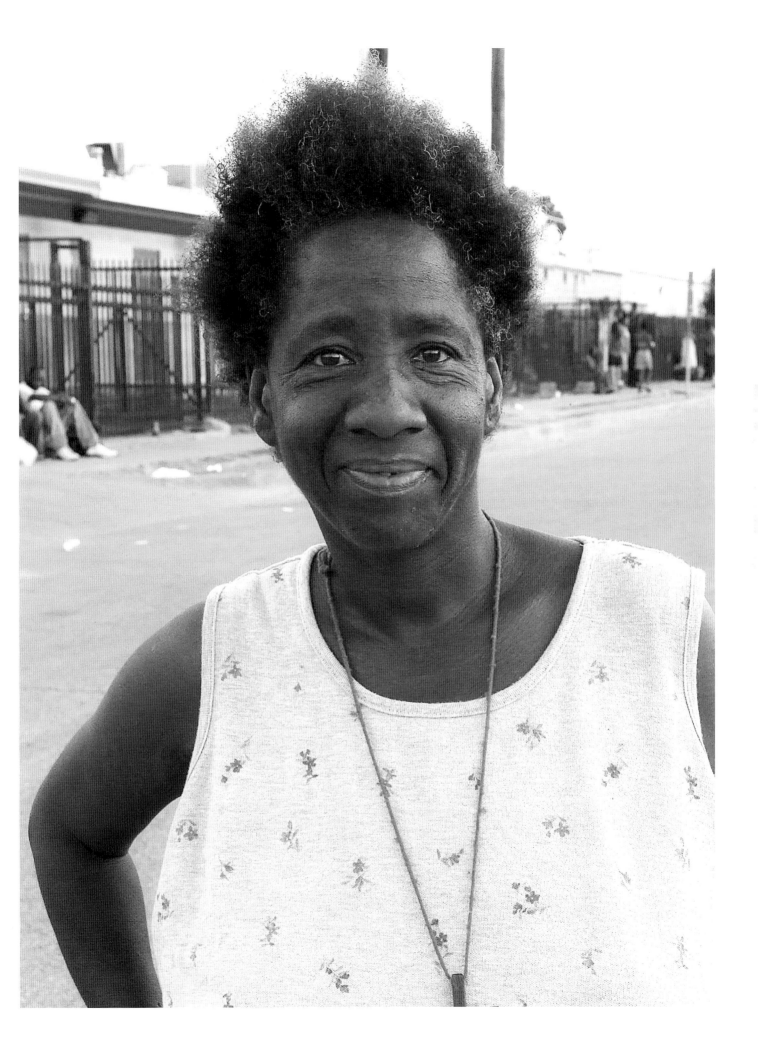

Richard was born in Boley, Oklahoma, on February 3, 1944. In his youth he was a Cub Scout, Boy Scout, and eventually an Eagle Scout. He lived in Rusk County, Texas, before moving to Fort Worth in 1979. He was medically disabled but received no care. His paperwork to receive disability wasn't complete, because like many homeless people, he was unable to provide his social security card and proper birth certificate. Although he did not tell me, I could tell by his actions that he suffered from a severe mental disability.

HE ASKED IF I HAD SOME ASPIRIN OR ANYTHING TO HELP WITH THE CONSTANT PAIN IN HIS HANDS— HIS FINGERS AND FINGERNAILS WERE ROTTING WITH GANGRENE, AND ONE HAD BEEN AMPUTATED— BUT I DID NOT HAVE ANYTHING TO OFFER.

OPPOSITE // **RICHARD'S HANDS**

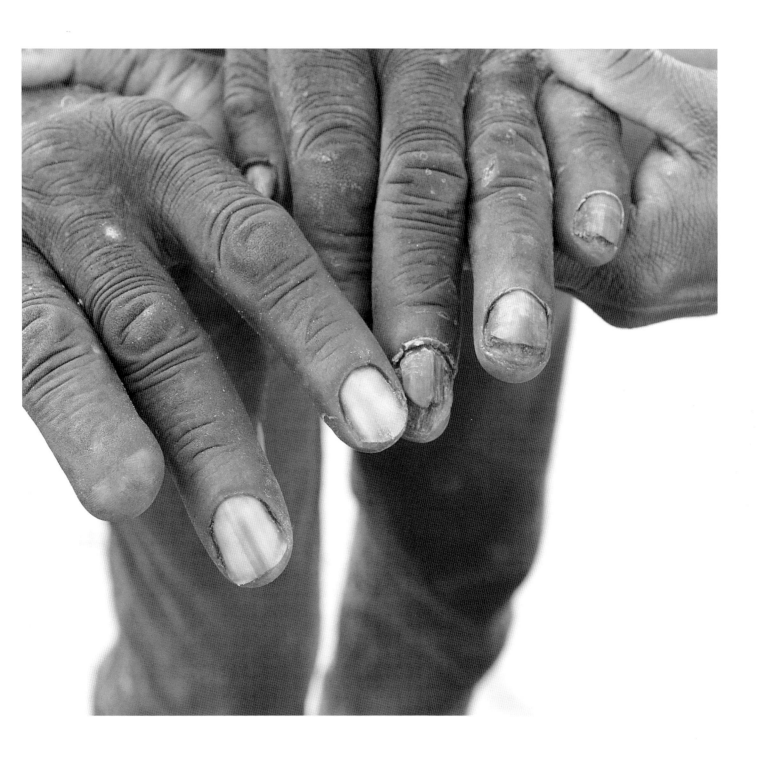

The three of us sat talking for a short while, and that is when I noticed his shoes: the soles of both were worn almost completely through. I asked him if I could take a picture of them. He shrugged, agreeing, but found it hard to believe that I wanted a picture of his shoes. I immediately thought of the quote by Thoreau, "How wonderful it would be if we could see the world through one another's eyes."

I thought to myself, these shoes would tell an amazing story if someone could walk in them for a while.

It was now about 7:15 a.m. Richard rose abruptly to get back to collecting cans before someone else got to them first. And it was time for me to meet up with Mike again. Last night he was supposed to find out about a couple of encampments we didn't get to the day before and take me to them. He greeted me with his wide smile, asking if I was ready for another day. I eagerly said, "Let's go." He told me he found out about Camp Swap A Ho, a camp of pimps, hookers, and dealers, that also harbored a meth lab. Mike thought that we should not go there because it wasn't safe, and even though a part of me really wanted to, I strongly agreed. I really wanted to infiltrate that camp, but knew it was a bad idea. There was another encampment of all Hispanics (most of whom were illegal or had just arrived), but, once again, Mike told me it would be too dangerous. They didn't speak any English and really didn't like outsiders. When Mike asked me where I wanted to go, I told him that I had brought all the items Anna had requested and that I'd like to take them to her before she left for the day.

I THOUGHT TO MYSELF, THESE SHOES WOULD TELL AN AMAZING STORY IF SOMEONE COULD WALK IN THEM FOR A WHILE.

OPPOSITE // **WALKING SHOES**

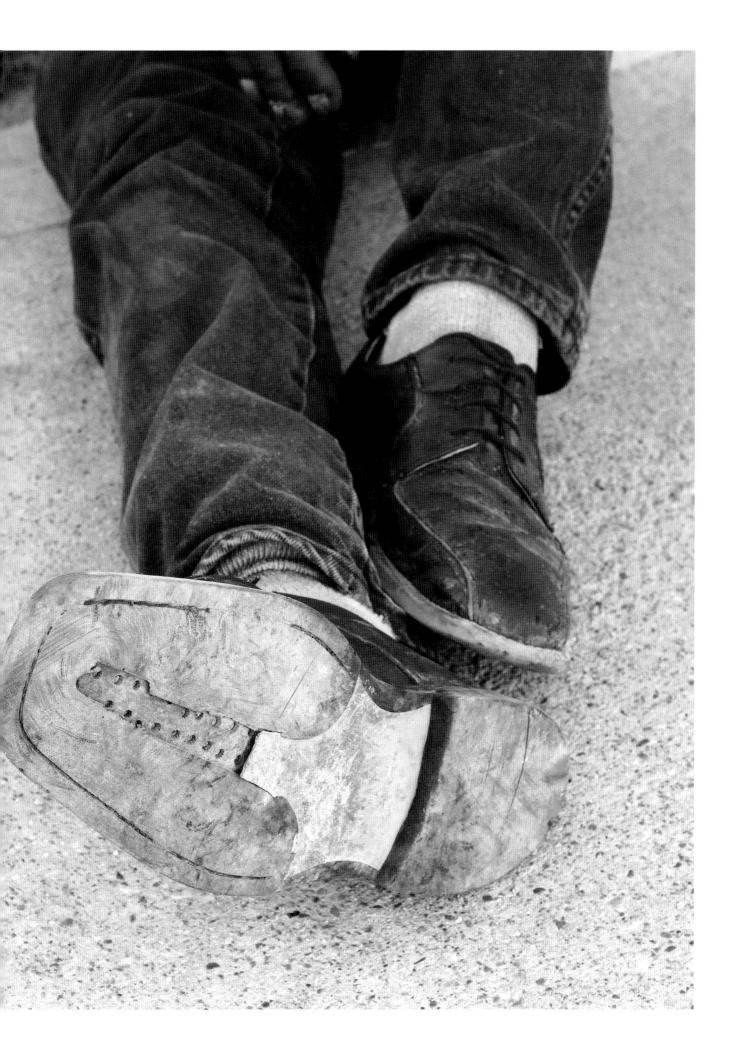

Trying to ignore the heat, we made the long walk down the streets, under bridges and overpasses, and through the thicket to her camp. We called out to her by name and she answered. I told her it was B.J. and Mike with the things she asked for. She invited us in and had an ear-to-ear grin as I handed her a totebag full of the items she wanted. I asked if I could do her portrait, but she once again declined.

While we were in a nearby encampment I noticed that a woman I had spoken with the day before had swollen, black and blue eyes. I asked her if she was all right, sensing her anxiety. She said her boyfriend told her that she had to be gone by today. He was mad because she did not keep up the place like he wanted her to. My heart sank, thinking that our coming to their camp and putting them at risk of exposure to the police might have played a part. I gave her a few ones I had stashed in my pocket, assuring her everything would be all right as we left her alone.

Mike and I left the camp. I was sickened by what I had seen and somehow felt responsible. My God, what if I caused that woman to be beaten? Mike said he saw the bruises on her face, too, and also wondered if it was because she talked to us. I told him, "How awful to be a woman out here in the woods with no one to hear you cry out for help." Mike said that if anyone could hear her they probably wouldn't come to help anyway. My heart sank even more as we walked to the next camp.

HOW AWFUL TO BE A WOMAN OUT HERE IN THE WOODS WITH NO ONE TO HEAR YOU CRY OUT FOR HELP.

RIGHT // **TRUCK HOUSE**

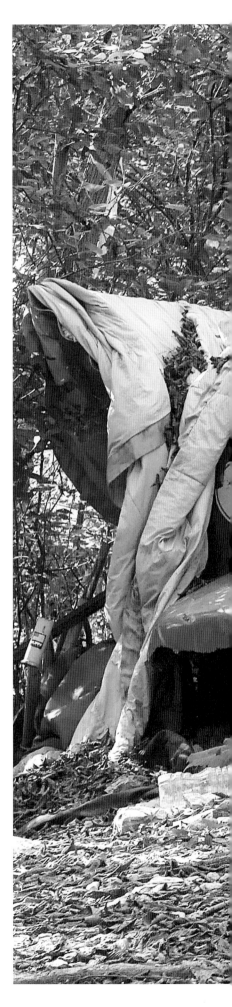

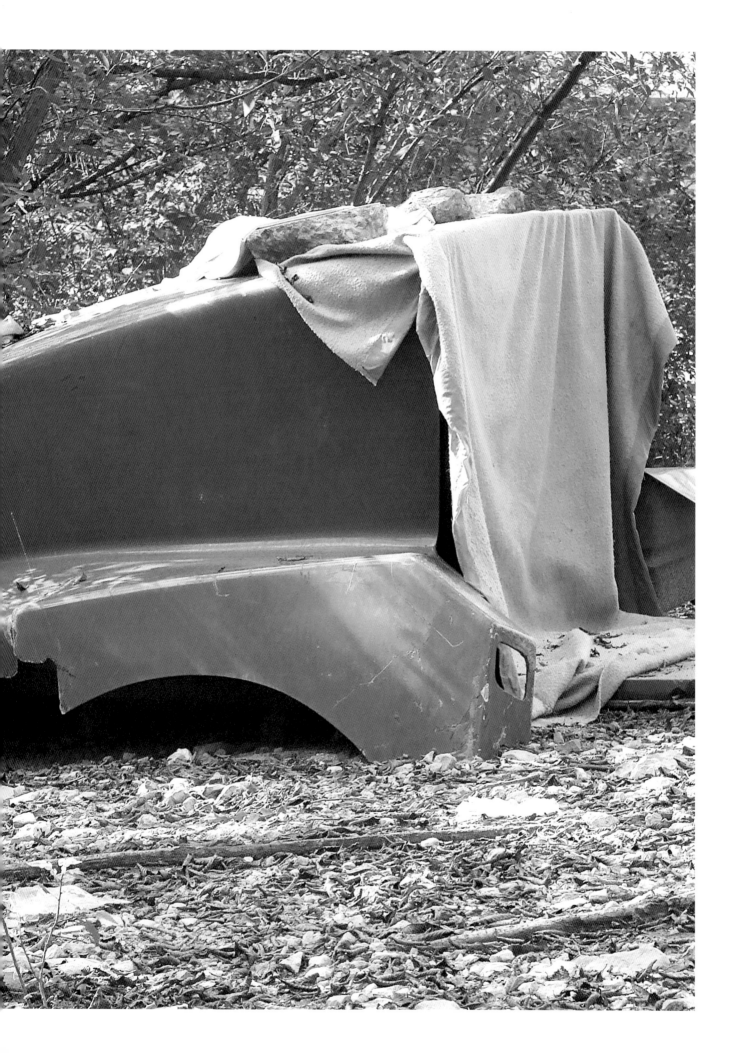

Mike and I came to a clearing where, the day before, I had photographed a shrine and an American flag flying under the bridge. Today there was a mattress with two people lying on it. Mike called out, and a tall, lean man rose up and headed toward us. Mike knew him. His name was Michael, age fifty-seven, born in Tyler, Texas. They greeted one another, and Mike introduced me. I told him what I was doing, and he agreed to be photographed. I was excited to learn about the people responsible for the flag and the shrine. I asked Michael what they meant.

The shrine was for his grandmother, who was killed on the highway right above their camp. She was hit by a drunk driver, her car careening over the guardrail.

They witnessed the tragedy and all the aftermath, not knowing the person was related. The flag was for his younger brother, who was killed in Iraq a week later, at the beginning of July 2009. I offered my sincere condolences, trying not to cry. Even though the homeless live on the streets or in the woods, it doesn't mean they don't have lives beyond that world. Most have family somewhere, many have children and grandchildren, and some keep in touch, but most are either estranged, have lost contact information, or are too ashamed to reach out to family.

When we arrived at the makeshift bedroom his wife was still asleep but beginning to stir. He said he wanted her to be in the pictures with him, but she was sleeping. He said he could wake her, but he didn't want to make her mad. He smiled widely and lifted a brow suggesting, "You know what I mean." His wife soon woke as we made small talk by the bedside. The moment she opened her eyes, they were cheerful and bright. She rubbed the sleep off and looked up, obviously wondering who was at their home so early in the morning. Michael told her to get up; they had company. She rose, and we introduced ourselves. Her name was Brenda, age fifty-four, born and raised in Fort Worth. I told her I wanted to photograph various folks to give a face to the homeless in Fort Worth, in an effort to raise awareness and possibly help raise donations for the shelters. She was all for it, wanting to help in any way she could. She, too, told me the story behind the flag and wanted to show me the shrine she had built for Michael's grandmother, Ernestine. We walked a few hundred yards, and when we arrived, I told her I wanted to take their photo by the shrine. They were delighted to have a picture made of them together, especially there.

THE SHRINE WAS FOR HIS GRANDMOTHER, WHO WAS KILLED ON THE HIGHWAY RIGHT ABOVE THEIR CAMP. SHE WAS HIT BY A DRUNK DRIVER, HER CAR CAREENING OVER THE GUARDRAIL.

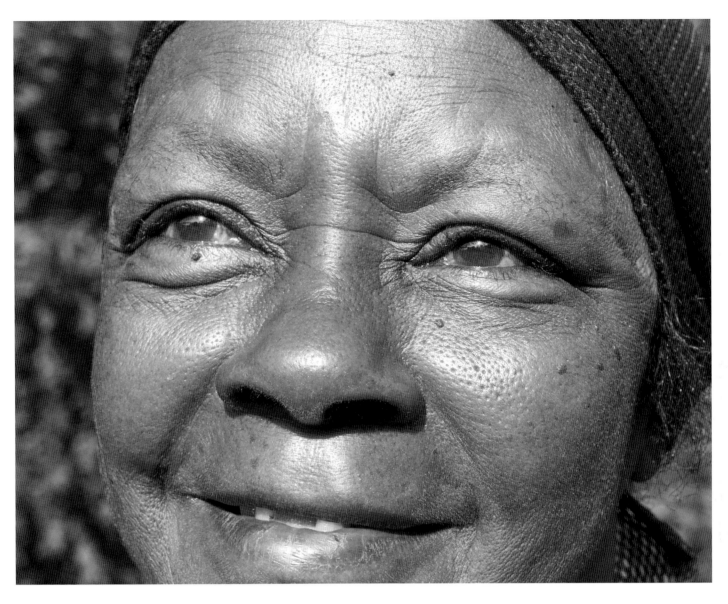

ABOVE // **EYES**
RIGHT // **MICHAEL**

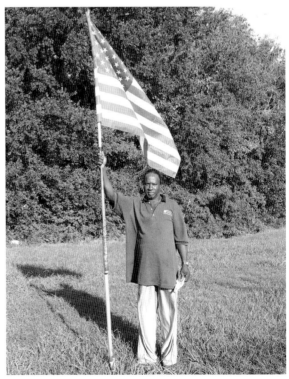

She insisted on showing me their real home—the one in the woods. She said they had to move out for a while because the bugs were bad due to the recent flooding. She took me in and showed me their various rooms, proud of her home like any good wife would be. I photographed her in her wooded surroundings as she stood tall and proud. My eyes could hardly take in everything I was seeing. Brenda made the place feel and look like a real home. She had decorations up all around: flowers in plastic bottles tied to trees looked like sconces on a wall. She was pretty organized for living in the woods. Clothes were on hangers on strings tied between trees. Each room had its purpose, just like the rooms we have in our homes. I noticed everything was really damp; some areas were still muddy and flooded from the recent, unusual August rainstorms. Both of us were covered in mosquitoes, and as we made our way out she said, "Now you see why we moved the mattress out under the bridge." We hurried out to the clearing to meet up with the men, who were talking. I photographed Michael by his brother's flag and listened as he told the story. His brother's name was Clarence, age twenty-seven. He was in the Marine Corps for a year and a half before he was killed by an IED, a roadside bomb. Michael was proud that the flag had actually been flown over in Iraq and that his brother was an American hero.

Mike and Michael made small talk as I jotted down Brenda's story. She told me she worked in the computer industry at Texas Instruments until her life was turned upside down. She had been the victim of an armed robbery. She was bludgeoned over the head with a crowbar and left for dead, and was in a coma for a long time. She really defied odds by surviving. When she recovered, it was not fully; she lost a lot of her memory and, as she put it, "my brains."

SHE WAS TOO WELL TO BE QUALIFIED AS DISABLED BUT CONSIDERED UNDESIRABLE AS AN EMPLOYEE. SHE MET MICHAEL AT THE SALVATION ARMY MORE THAN TEN YEARS BEFORE, AND THEY HAD BEEN TOGETHER EVER SINCE. I COULD TELL THEY WERE IN LOVE; BRENDA NEVER STRAYED FAR FROM MICHAEL'S SIDE.

OPPOSITE // **BRENDA AT HOME**

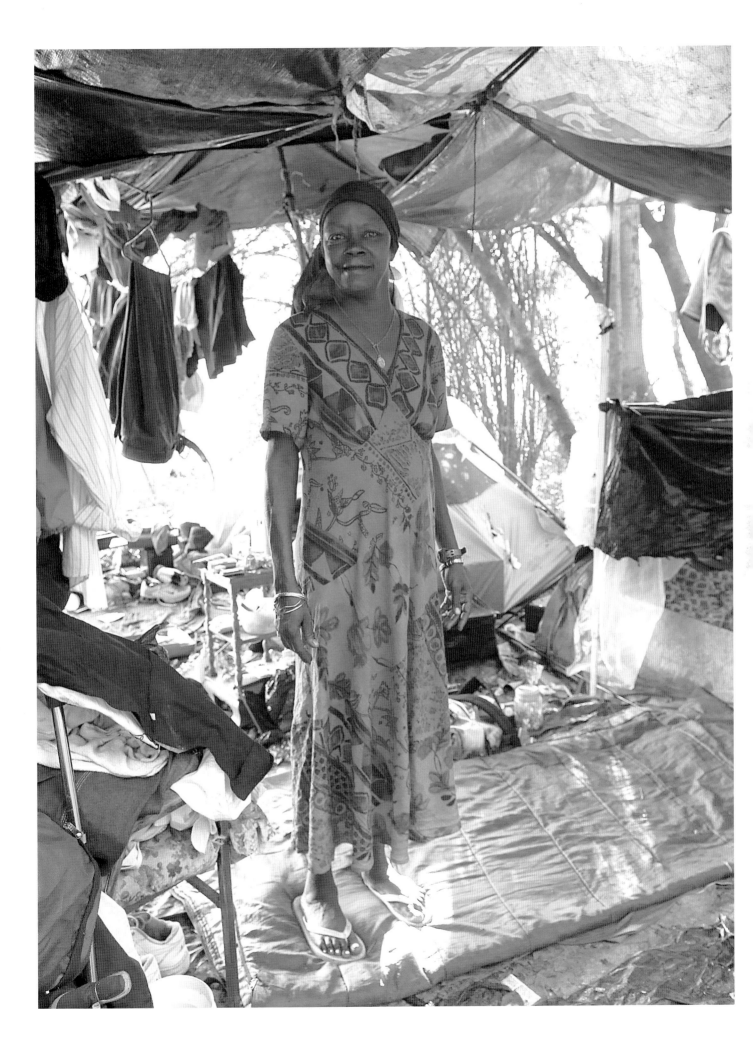

As Michael was talking, Brenda looked up at him. That was when I noticed her amazing eyes and asked if I could take a close-up of just her eyes. Since it was digital, I let them both take a peek at the back of the camera. That's when Michael said, "Those beautiful eyes are her window to the world." We walked back to where the mattress was lying in the wet grass and stood around talking for quite some time. I asked if I could shoot a few things close by that caught my eye.

They had an old, beat-up charcoal grill, their only means of cooking meals. There was a small jar of something on a wire shelf at the bottom of the grill. I didn't see any food around, so I asked if they needed any food and what kind of food she would like me to bring back. Without hesitation, she blurted out, "Meat." I later found out that meat is one thing you cannot buy at a convenience store or a dollar store. Lots of unsheltered homeless people trap raccoons, opossums, and squirrels for a source of meat in their diets.

The other thing that caught my eye was one of those wire carts used to haul stuff, usually seen at flea markets.

LOTS OF UNSHELTERED HOMELESS PEOPLE TRAP RACCOONS, OPOSSUMS, AND SQUIRRELS FOR A SOURCE OF MEAT IN THEIR DIETS.

OPPOSITE // **BRENDA'S STOVE**

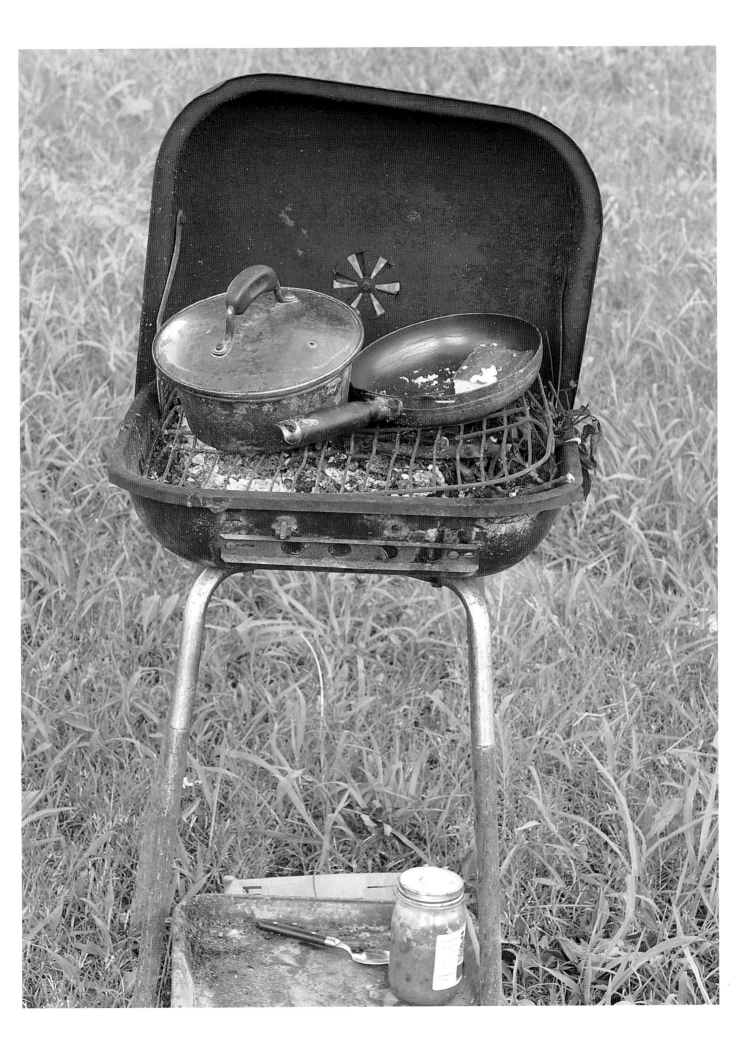

It was fully loaded and I was almost certain that the 4x4 mud tires on the back of Brenda's cart were a custom add-on. Two teddy bears and the word "Hope," carved in wooden letters, hung from the front of the cart. *A perfect representation of their lives*, I thought. Two companions traveling through a life held together with duct tape, string, found objects, and hope. Hope being the common denominator among all the people on the streets that I had met so far. When I asked her what keeps her going every day, she said, "Michael and a whole lot of the Lord." They both attended U-turn Church every Sunday. They had applied for public housing, but their caseworker quit and their papers were lost, so they had to begin the process all over again. When we were leaving, I told them I would put them both in my prayers and hoped that everything would work out soon with their housing. Brenda and Michael had been living from camp to camp for more than ten years.

BRENDA AND MICHAEL HAD BEEN LIVING FROM CAMP TO CAMP FOR MORE THAN TEN YEARS.

RIGHT // **STRING AND DUCT TAPE**
OPPOSITE // **HOPE**

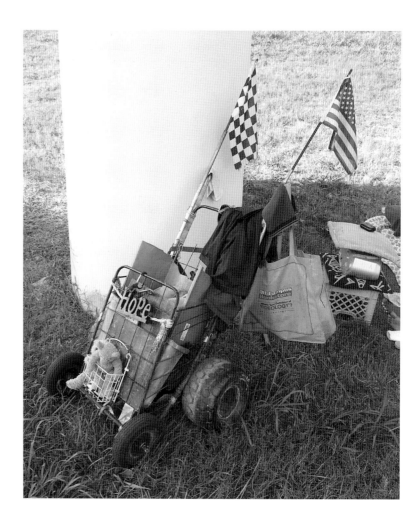

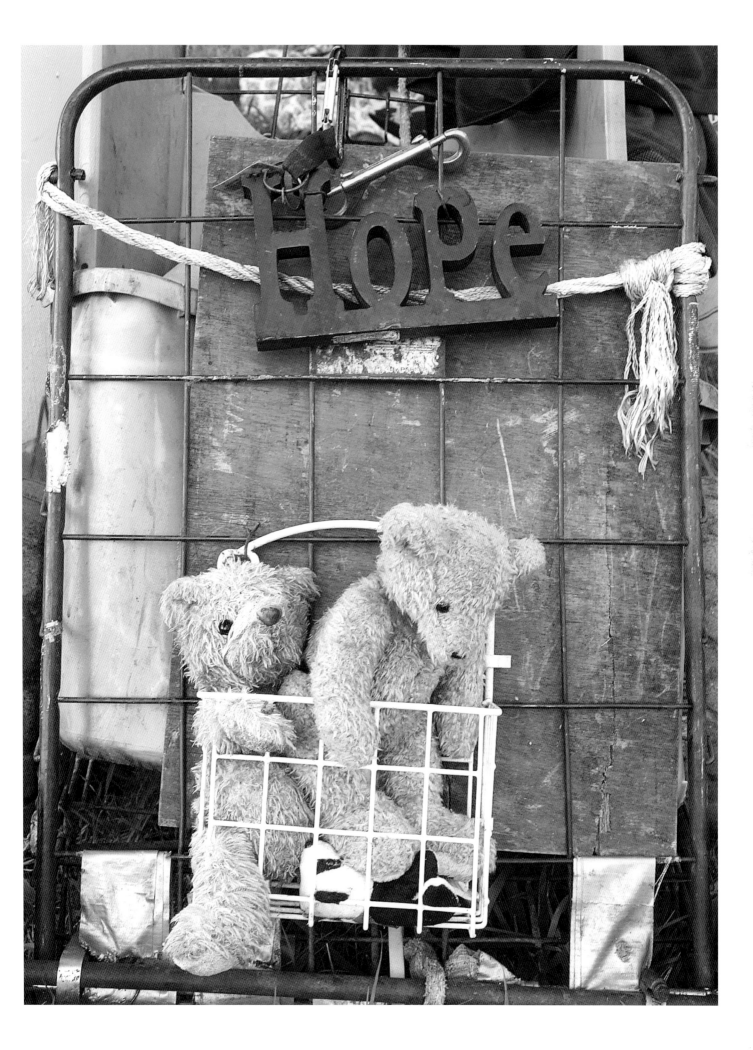

Mike and I returned to street level and began meeting more people. I sat down with Cailesse, born on April 7, 1962, in Lincoln, Nebraska, and her boyfriend and hero Sebastian, who was born in Houston, Texas, on October 15, 1965. Sebastian and Cailesse met ten years ago in Tyler while working for Magic Valley Rides, a carnival company. Cailesse was involved in an abusive relationship before meeting Sebastian. She told me her husband broke her leg to collect insurance money and beat up her father when she went to him for help, breaking his arm in seventeen places. Sebastian and Cailesse wanted to get married, but she was unable to file for a legal divorce because she didn't want her husband to find her. After suffering from three strokes and two heart attacks in the past three years, she was confined to a wheelchair. Sebastian told me he lives his life for Cailesse, pushing her everywhere she needs to go. He worked doing landscaping when he could find it, but was willing to do any type of work. He was having difficulty in his job search because his ID was stolen while he was doing laundry ten months earlier. When I photographed them, I saw the anguish in their eyes, their skin burnt and sore from daily exposure to the torturous rays of the sun. Just as I was about to move on, they asked me if I knew of anyone who had a wheelchair they might give Cailesse, because the wheel kept coming off the one she had. My heart sank again as I began to realize that every person out here had a need. I looked around and saw a massive number of people. That was a lot of needs. Certainly more than I could handle on my own, even though I wished I could fill them all right then.

EVERY PERSON OUT HERE HAD A NEED.

OPPOSITE // **SEBASTIAN AND CAILESSE**

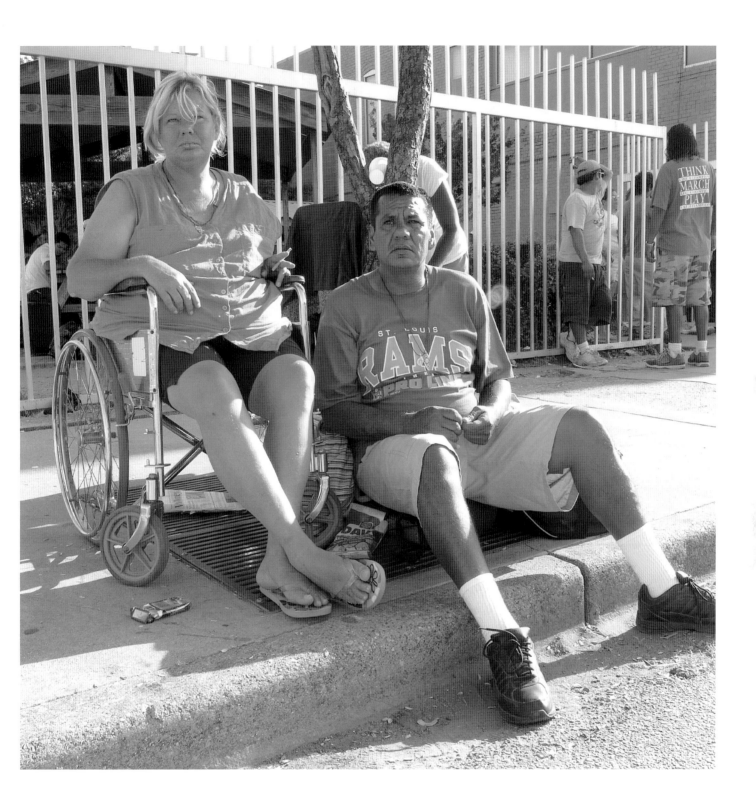

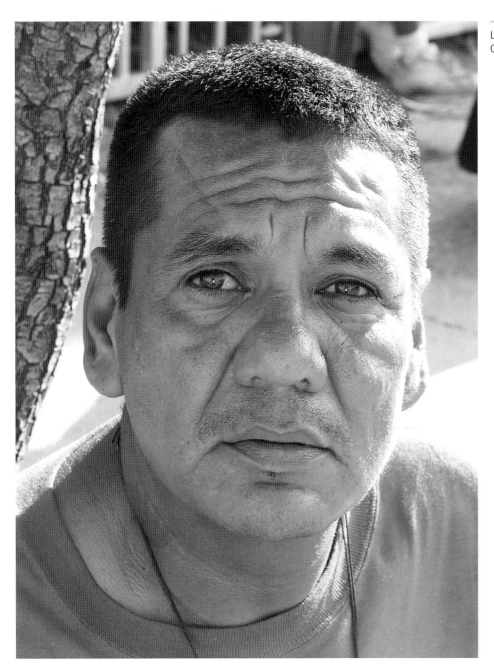

LEFT // **SEBASTIAN**
OPPOSITE // **CAILESSE**

I SAW THE ANGUISH IN THEIR EYES, THEIR SKIN BURNT AND SORE FROM DAILY EXPOSURE TO THE TORTUROUS RAYS OF THE SUN.

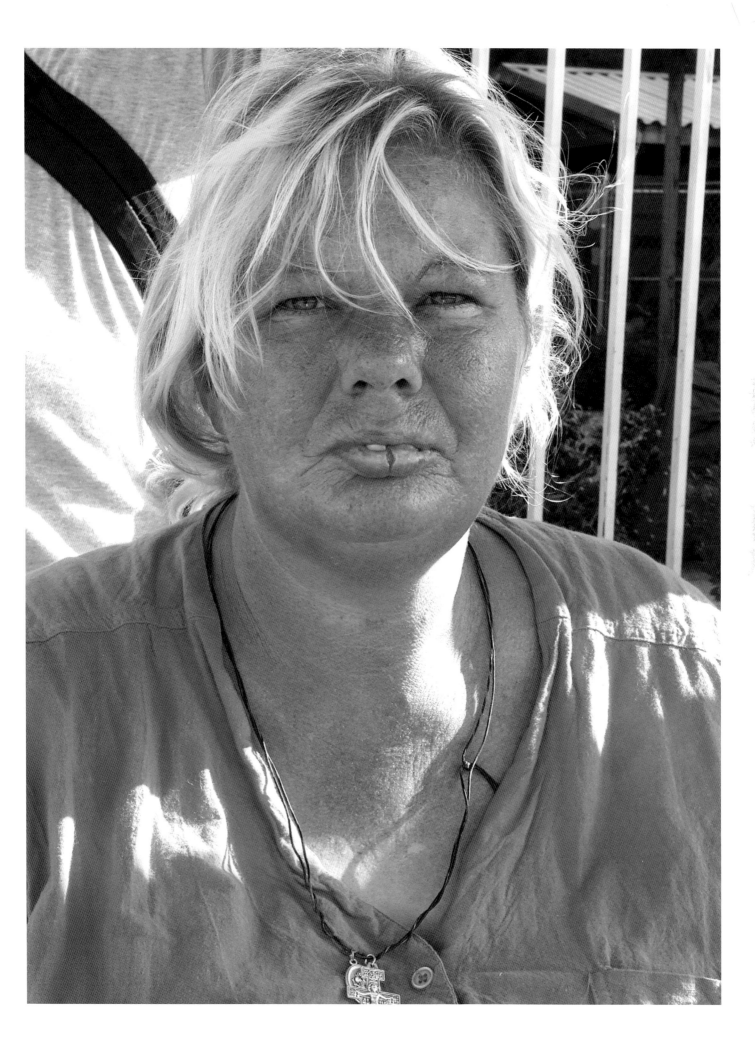

I made my way down the street, photographing everything I witnessed. A young girl dressed in all white sat alone with her head resting on her arms. She never moved and never looked up, not even noticing as I took her photo.

I LOOKED AT THE WHITE BARS ON THE FENCE BEHIND HER, THINKING ABOUT HOW SIMILAR BEING IN JAIL AND BEING ON THE STREETS REALLY WERE. THE STREET ENVIRONMENT AND THE OBSTACLES ONE MUST ENDURE AND OVERCOME TO GET OUT ARE A PRISON IN THEMSELVES.

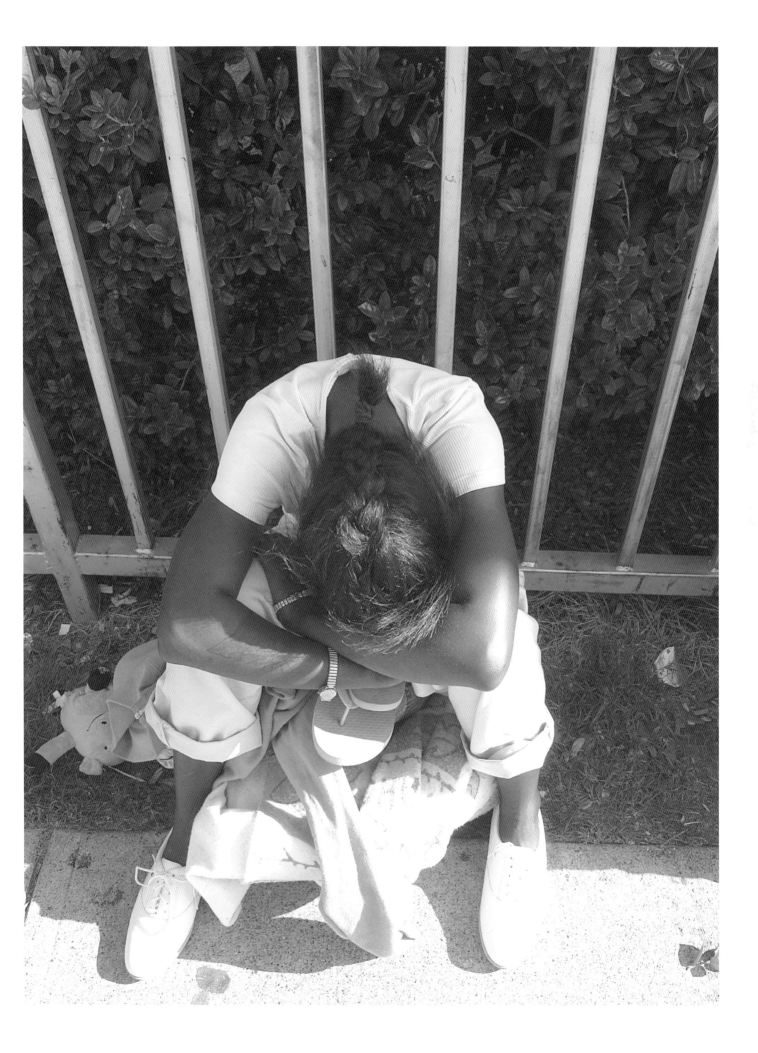

Starting to despair, I kept moving. I passed by a sleeping man in the middle of the sidewalk.

PEOPLE STEPPED OVER HIM AS IF HE WAS MERELY AN OBSTACLE TO BE AVOIDED. EVEN ON A 115-DEGREE DAY, SLEEP EVENTUALLY COMES ON THE STREET. IT IS CHANGE THAT SEEMS TO TAKE FOREVER.

Michael, not Brenda's Michael, was the next willing person to share his story. Michael was a Navy veteran who served six years with two tours overseas. He resided at the Patriot House and was working on getting his life back on track. He moved here from California to be with his girlfriend, and had obtained his commercial driver's license and was looking for work as a truck driver. He suffered from depression and post-traumatic stress disorder.

He had been addicted to crack cocaine, but had been clean for a year and six months. He had a very positive attitude, and I believed he was very close to being integrated back into society to contribute in a positive way.

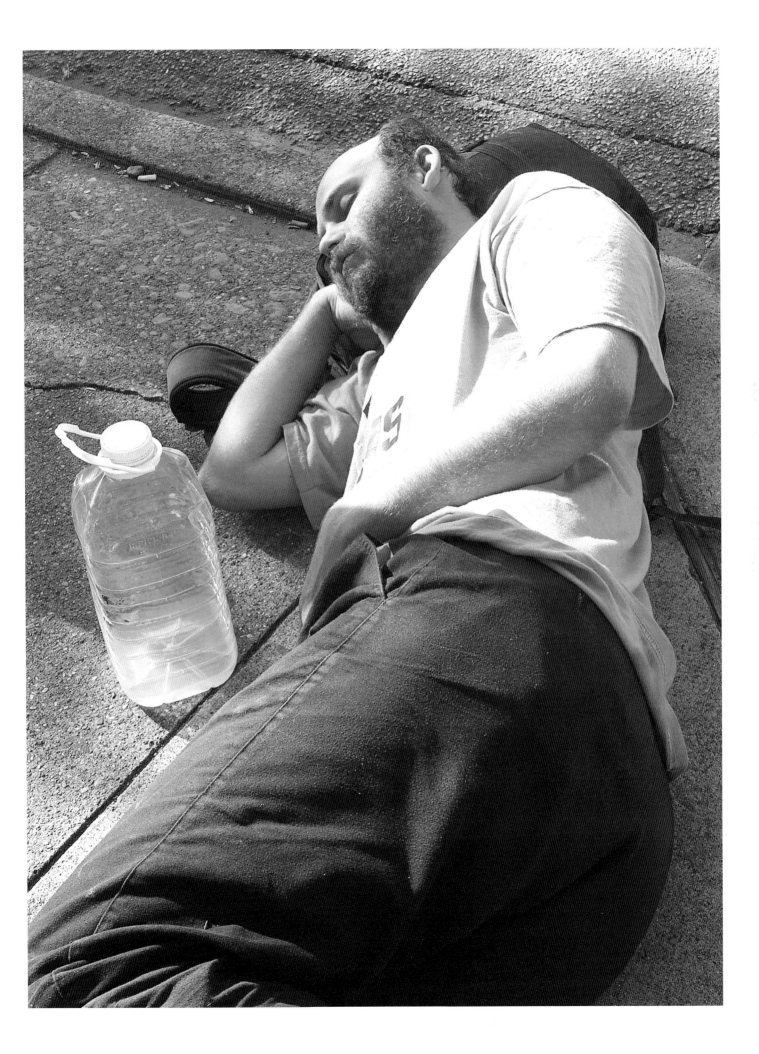

I sat down on the sidewalk, my back up against the wall of an old building as I watched the sun rise on Lancaster Avenue for the last time. I looked to the left and watched a woman in a wheelchair make her way down the crumbling sidewalk. A pigeon walked just ahead of her, looking back as if to say, "Follow me." I captured a few images, saving that moment in time. The image had two subjects: one that could fly away and become invisible in an instant, and one that could never get away but was nevertheless invisible to most of us every day.

Saturday was a very different day on the street. It was the day when many caring citizens and church groups served coffee and food. The mood that Saturday was much more relaxed, and the people on the street seemed at ease. I guess it was much like a typical Saturday in our lives, another week ended and a time for relaxation and fun.

MOST HOMELESS WORE WATCHES. THEY NEEDED TO KNOW WHEN TO BE AT THE RIGHT PLACE, AT THE RIGHT TIME, TO RECEIVE THE HELP THAT CAME ON WEEKENDS: 5:00 A.M. CEREAL AT ONE CORNER, 9:00 A.M. COFFEE AT UNITY PARK; AT HIGH NOON, A HOT MEAL OF BREAD, BEANS, AND A SWEET ROLL SERVED BY A COUPLE OF WOMEN AT A PARKING LOT.

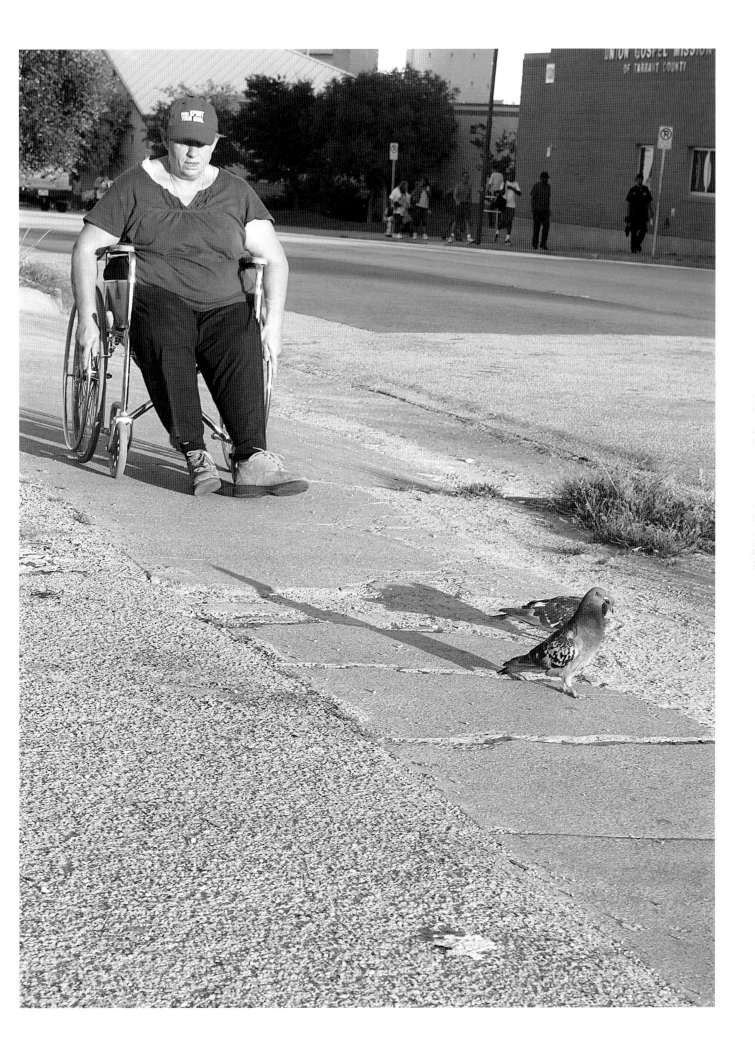

It wasn't long before I met William, or "Wild Bill" as he is known on the street, born on August 18, 1949. He came to Fort Worth in 2004 after losing his license to practice his trade as a plumber. He had a positive attitude and was kind and funny. Many people liked to hang out with him, because he was a good friend to all and had a satirical streak that made him fun to be around. We made small talk as I sat with him on the street corner. He told jokes, and I took pictures.

HIS BODY WAS EMACIATED AND FRAIL BECAUSE HIS ONLY NUTRITION CAME IN THE FORM OF LIQUID BREAD, OR, IN OTHER WORDS, BEER.'

OPPOSITE // **WILD BILL**

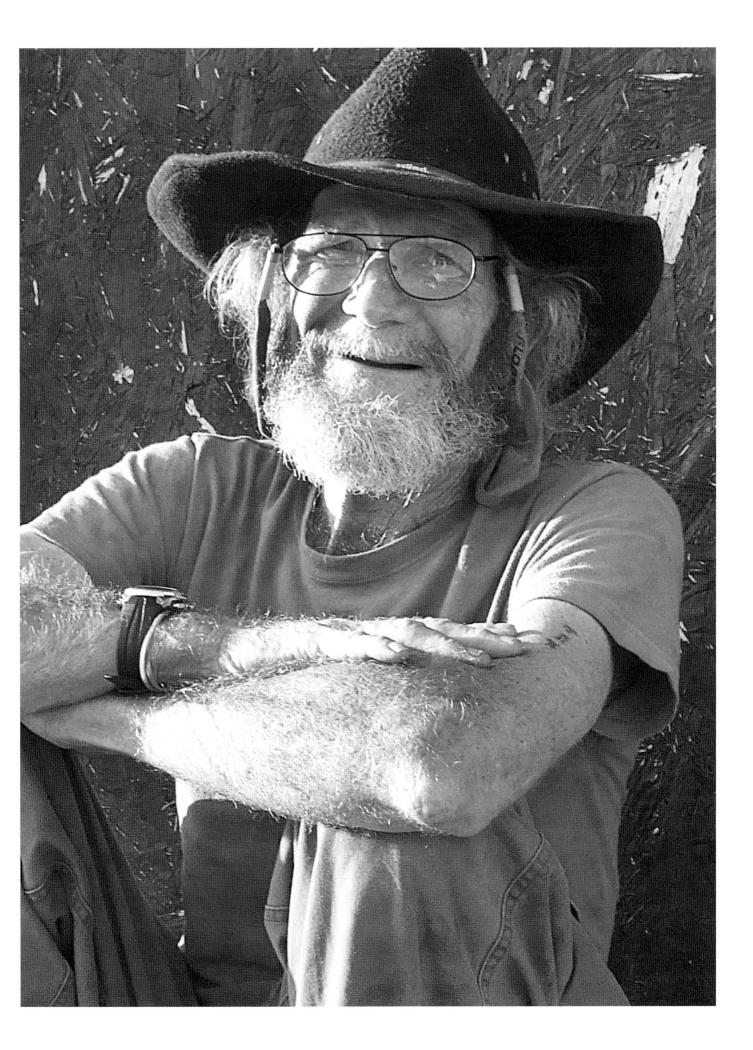

A young man rolled up in front of us
in a wheelchair and sat watching the
cars whizz by. On the street, this man
was styling just as much as the man in
the Mercedes that was just then streaking
down the street.

HIS SET OF WHEELS WERE VERY MUCH A LUXURY ITEM FOR A HOMELESS PERSON.

OPPOSITE // **WHEELS**

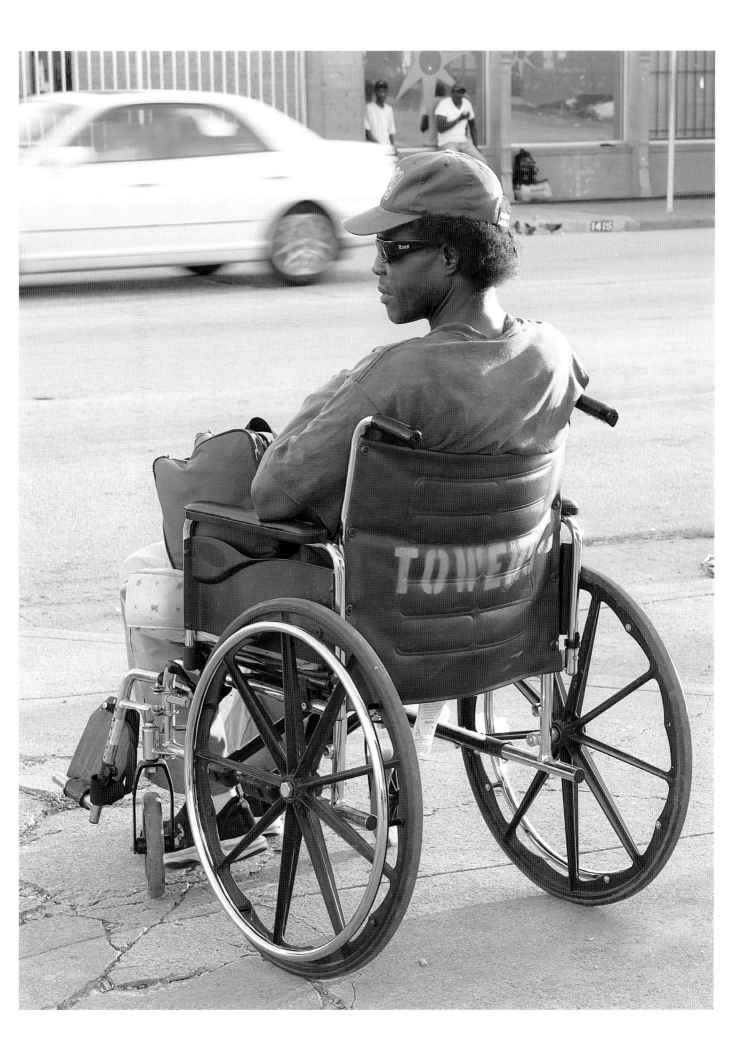

I followed the flow of people on the street to Unity Park. I entered the fenced area and took photos of people milling around and visiting with friends. The pace of life was different here: slow, casual, and very friendly. Here I found picnic tables filled with people enjoying coffee with cream and as many sugars as they wanted, for free. I sat with several folks talking about their personal lives. I sat down and visited with as many people as I could and learned a lot about life, love, and the harsh existence of life on the street. I found out the streets were filled not only with good people but with some very bad ones as well. Many convicted felons recently released from prison ended up on the street. They were released with no money, no clothes, no job, and could not be considered for public housing or benefits for ten years.

There were many sex offenders milling around that most of the homeless people shunned and wanted no part of. These unsavory types were quickly pointed out, their presence made known to everyone else.

MANY CONVICTED FELONS RECENTLY RELEASED FROM PRISON ENDED UP ON THE STREET. THEY WERE RELEASED WITH NO MONEY, NO CLOTHES, NO JOB, AND COULD NOT BE CONSIDERED FOR PUBLIC HOUSING OR BENEFITS FOR TEN YEARS.

OPPOSITE // **A HOT MEAL**

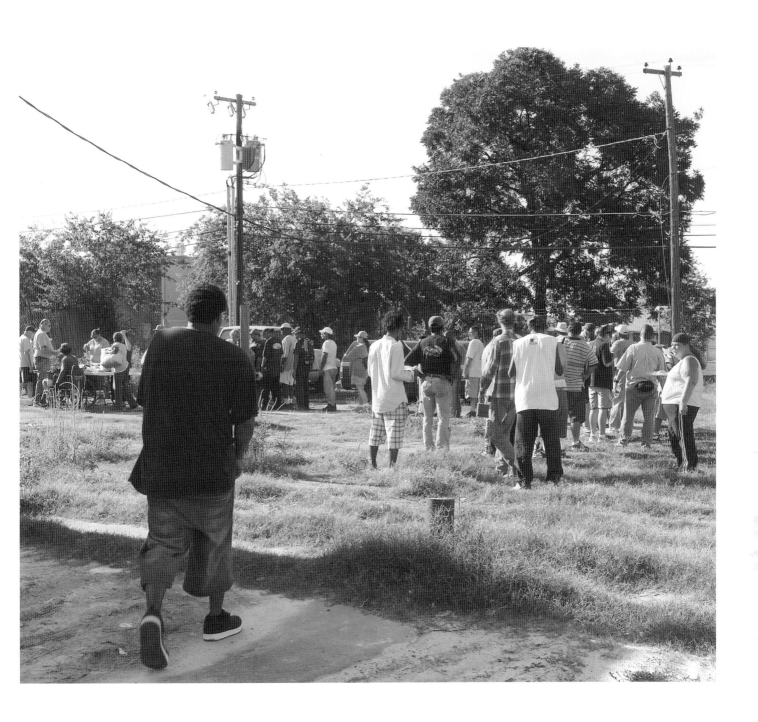

I also learned that, on Saturdays, the street was filled with many folks who were not from the shelters or the street, but from the nearby projects.

These people knew that food was available and, sometimes, clothing and shoes, so they showed up to take advantage of the generosity of the caring citizens who came out on Saturdays. It seemed to me that the shelter people liked their company and looked forward to a fresh set of faces in their territory.

SATURDAYS WERE A DAY OF LEISURE, SHARING STORIES, AND CARING.

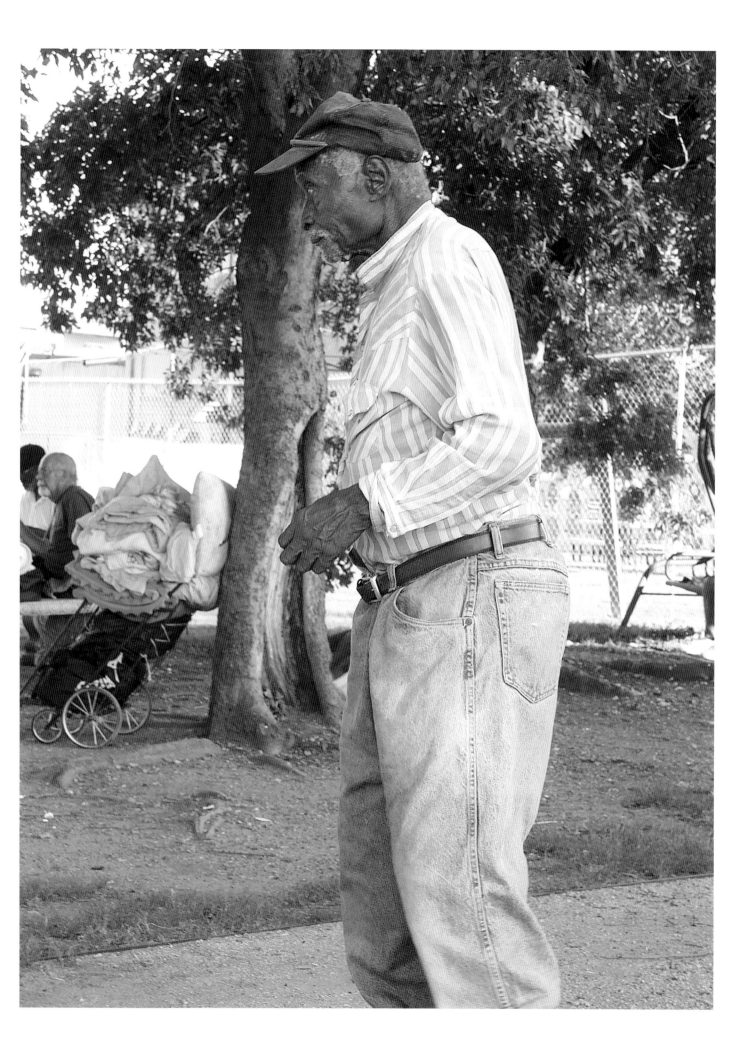

My last interview came from Eric, a fifty-year-old native of Fort Worth. He sat with me and my other newfound friends at the table. I finally got him to agree to a photo shoot and to open up about his life. He worked in the upholstery business for more than twenty years, but then work just dried up. He had two grown daughters, twenty-six and twenty-seven years of age, but he had not seen them in years. When I asked him what kept him going every day, he told me faith in God. He said, "If you don't have faith, you don't have nothing." He wakes every morning and gives thanks to the Lord for another day. Eric was very kind and had an incredible sense of humor. He was very concerned for my well-being while I was out on the streets doing what I was doing. I told him that I had not once felt in danger or threatened. He thanked me for trying to help. As we parted ways, he said he would pray for good things to come from my hard work, and I thanked him for the kindness.

I sat with Sherry, whom I had met a couple of days before, and talked for a long time. I waved and said hi to people I recognized from the days before and tried to remember all of their names. Calling people out here by name really meant something; the gesture brought back a bit of the pride they had been missing. They realized that they were still *somebodies* who had names and some significance in life. Sherry and I stayed in the park until late afternoon. I listened and learned, and she enjoyed the company of someone who treated her with respect for a change. My last day was coming to a close as we walked back to my truck. Sherry told me she was going to go to her favorite peaceful spot by the river and watch the sunset. I wanted to give her a parting gift, but all my goodies were handed out, and I had no more money. I did, however, find a gold dollar coin I had tucked away in my wallet for good luck, so I gave it to her and told her she could spend it or keep it as her good luck charm to help her find her way off the streets. She said she would keep it forever. We both smiled and hugged goodbye; the perfect ending to a grueling three days.

I drove home half-relieved that this part of the project was finished, but I also felt hollow and sad for all the people I was leaving in my rearview mirror. It was difficult to drive away knowing that I would never stop worrying about them all: wondering where they were, if they were safe, or if they would find a way out. I met really kind people I will never forget and made new friends. I now more fully under-stand the many needs, the daily challenges to survive, and the undeniably grim cycle of homelessness that is so hard to break. Some of the tremendous problems are systemic and some are self-inflicted, but all need to be addressed somehow, some way. As I headed home I felt enlightened, and yet with every answer came ten more questions. I found it very difficult to get their faces, their voices, and their stories out of my head; I felt torn between two worlds. I wondered if this numbness inside of me and this profound sense of sadness would ever go away. Was it selfish to want it to? I made a promise to them, and to myself, that I would always try to help in any way I could, whether it was through my photography, by volunteering more, by acting as their voice, or by helping to convince others that we can and must lift these people up out of homelessness and help stop it from happening in the first place.

I AM NOW BOUND TO FULFILL A NEW PROMISE TO MANY MORE PEOPLE THAN JUST JOHNNY FROM 1985.

OPPOSITE // **ERIC**

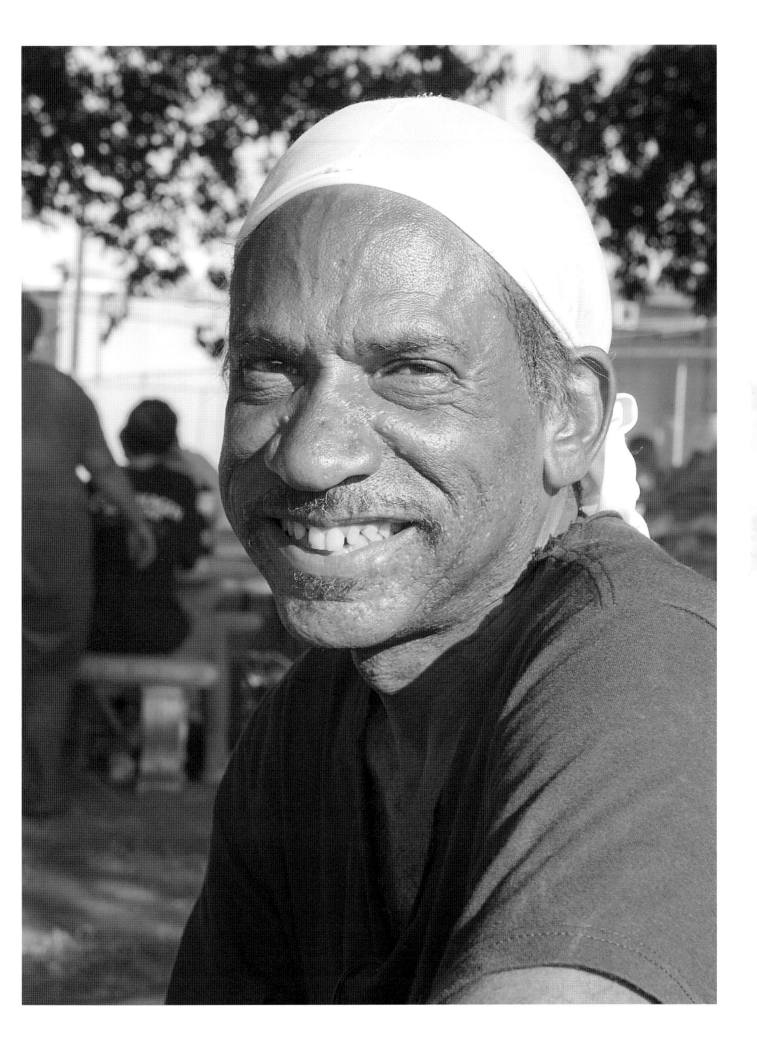

THE RETURN:
TWO YEARS LATER

In Spring 2011, I was once again asked to volunteer to take on an assignment involving the homeless in Fort Worth. Actually, the formerly homeless. I was excited and intrigued from the moment I received the call. The project's objective was to document numerous individuals who were homeless at one time and are now housed, recovering, and living lives with promising futures.

THESE IMAGES ARE PROOF THAT WHEN A CITY'S LEADERS, TAXPAYERS, AND AGENCIES— AS WELL AS THOUSANDS OF ITS CARING CITIZENS— COME TOGETHER TO TAKE ON THE PLIGHT OF HOMELESSNESS, REMARKABLE THINGS CAN HAPPEN.

OPPOSITE // Taura holds the key that opens the door to her home. This key also opens the door of opportunity for her to choose a different path in life. Her pet dog provides love and companionship, two elements that nurture the seeds of change.

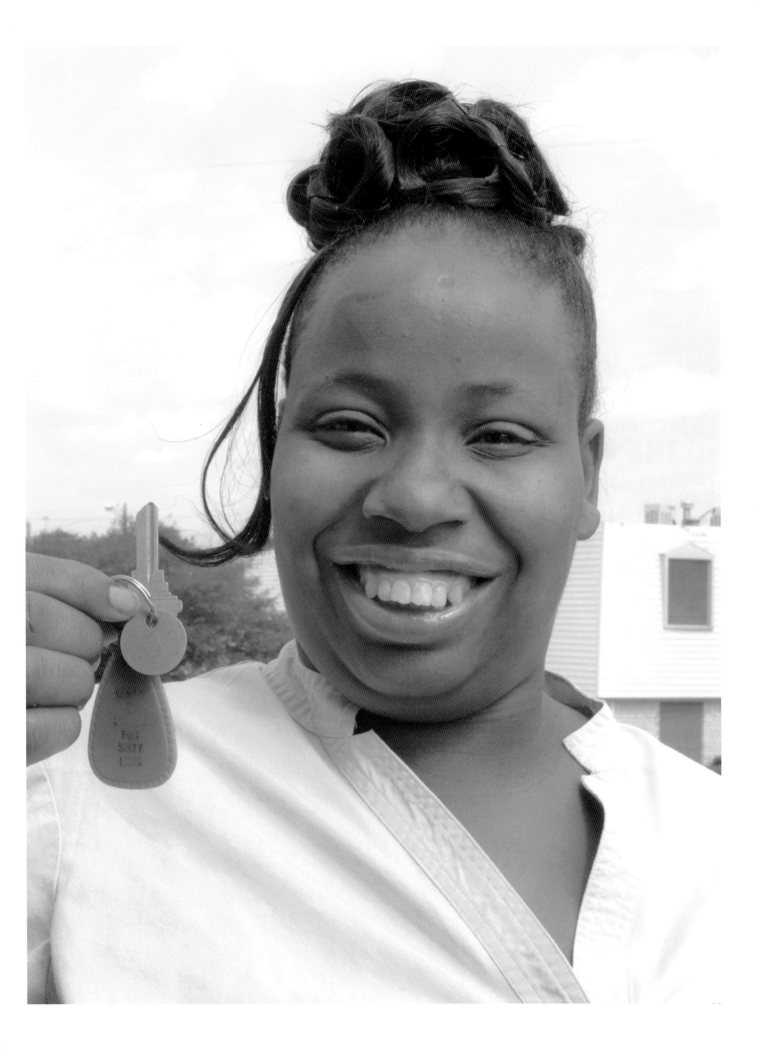

The executive director of the Tarrant County Homeless Coalition, Cindy J. Crain, contacted me and told me that she was planning a surprise going-away party for Mayor Mike Moncrief, who was retiring after four terms in office. She provided me with a list of individuals who were now in homes thanks to the tremendous efforts of various agencies and their personnel who had worked tirelessly to improve the lives of the homeless. All of the homeless that were now housed were invited as guests, and some even asked to participate.

THESE IMAGES WERE PART OF A PRESENTATION THAT WAS BOTH AN EXPRESSION OF GRATITUDE TO THE OUTGOING MAYOR FOR HIS LEADERSHIP IN THE CAUSE AND A CELEBRATION OF THE YEARS OF INNOVATION AND DEDICATION THAT MADE THESE SUCCESS STORIES POSSIBLE.

OPPOSITE // **Juanitane received housing through *Directions Home* and is working hard in job training and life skills classes to get back on her feet so that she can live a fulfilling and independent life.**

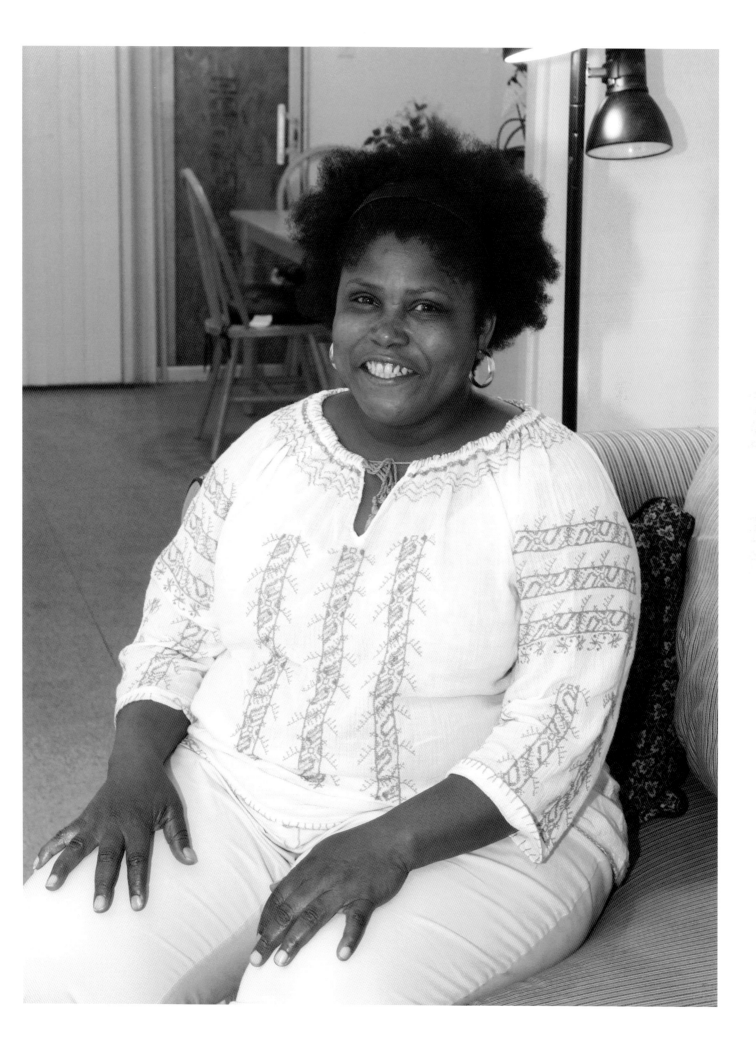

I was given a schedule of times, names, addresses, and phone numbers of all the people I was to photograph over the next few days. The night before I had my first shoot, I spent hours on the computer pulling up maps of all the locations, trying to figure out how I was going to get from place to place, since most of the appointments were scheduled thirty to forty minutes apart.

The first location was a Section 8 housing apartment complex built in the early eighties, leaving a lot to be desired from the outside. I was a little nervous and unsure of what to expect as I walked up to knock on the first door. When it opened, a well-dressed young lady sporting a smile on her face and a noticeable sparkle in her eyes greeted me. She welcomed me inside her sparsely furnished but well-kept apartment, and after we introduced ourselves I thanked her for her participation in the project. She invited me to sit down on her sofa, and we began to talk about her home, her past, and her present situation. It only took a few moments for me to notice a tremendous sense of pride and overwhelming gratitude for the second chance she had been given. Time was passing way too quickly, so I asked her to show me around and choose the perfect spot to take her portrait. She gave me the grand tour of her one-bedroom home, all the while grinning from ear to ear that all of this was hers. Her bedroom had only a mattress on the floor, because the bed frame she received did not fit the mattress. Her living room was furnished with a sofa, a coffee table, a lamp, and a very old TV on a makeshift stand. Her kitchen had a table with one chair placed in front of a boarded-up sliding glass door that led to a small, now inaccessible patio. I photographed her in both the kitchen and living room, wanting desperately to capture the joy in her eyes and heart. As she led me to the door to say good-bye, I hugged her and told her how proud I was of her for working hard to change her life. I went to two more places, trying to stick to my rigorous time schedule, and met two more women in almost identical living situations. Both were filled with pride and joy, and were overwhelmed with gratitude for their second chances in life.

IF I HAD ONLY KNOWN HOW TRANSFORMATIVE THE PROJECT WOULD BE, I WOULDN'T HAVE SWEATED THE SMALL STUFF.

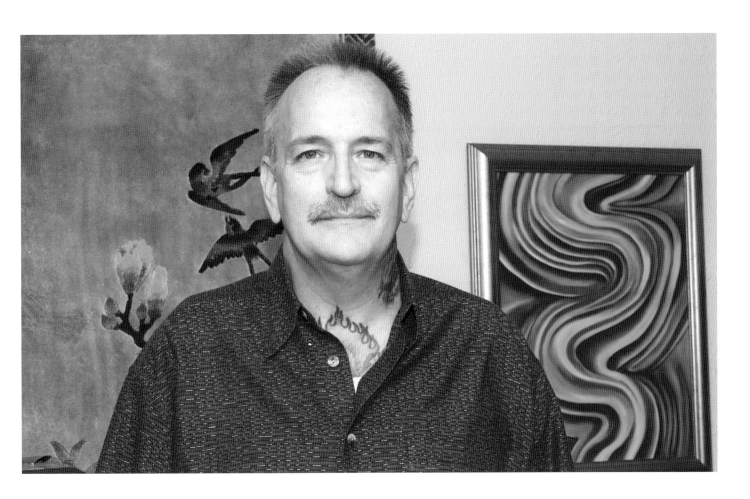

ABOVE // James is the first to tell you that without the help of the city's homeless initiatives, he would not be alive today. He is a recovered addict and a cancer survivor, and now he plays a major role in helping the homeless by being a volunteer spokesperson.

RIGHT // Melissa is recovered, restored, and stronger than ever, both physically and spiritually. She is working full-time and will soon be proudly independent of subsidized housing.

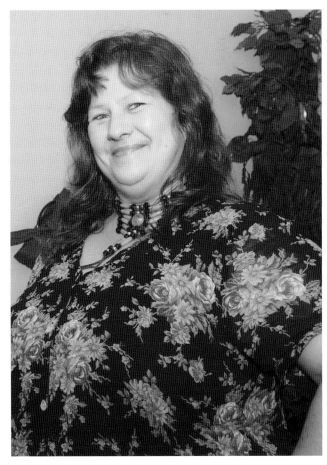

The next door that I knocked on and the face I saw when the door opened stopped me in my tracks and left me speechless. I found myself standing in front of Anna, the woman I photographed almost two years ago in the camps. I stood there, dumbfounded, as my mind raced backward to the place and time that we first met. I broke the silence by exclaiming, "Anna!" and fumbled my words as I tried to ask if she remembered me, a huge smile beginning to fill my face. She said, "Of course I remember you. I was looking forward to seeing you again when I was told you would be the photographer coming today." She invited me inside and my heart raced with excitement. Suddenly, I felt like I was floating or lifting off the ground with every step forward, and, in an instant, I knew what this feeling was: all the sorrow and worry for Anna that I had been carrying around deep inside of me was leaving.

Seeing her now was amazing. She was whole again, all the sadness and depression was gone and replaced by a look of peace. Anna was relaxed and happy, the tyranny of street life removed from her spirit. Seeing Anna in her home, smiling and safe, was one of the most joyful moments of my life. Anna was excited to show me all the amenities she had, like a shower with a real curtain, a closet with hangers, utensils in the kitchen drawers, and a cold refrigerator with food in it.

I ended up spending much more than my allotted time with her. Before I left, she asked me if we could say a prayer together to bless her house. Afterward I hugged her goodbye, feeling such joy that I barely held back a flood of tears until I made it to my truck.

I FOUND MYSELF STANDING IN FRONT OF ANNA, THE WOMAN I PHOTOGRAPHED ALMOST TWO YEARS AGO IN THE CAMPS.

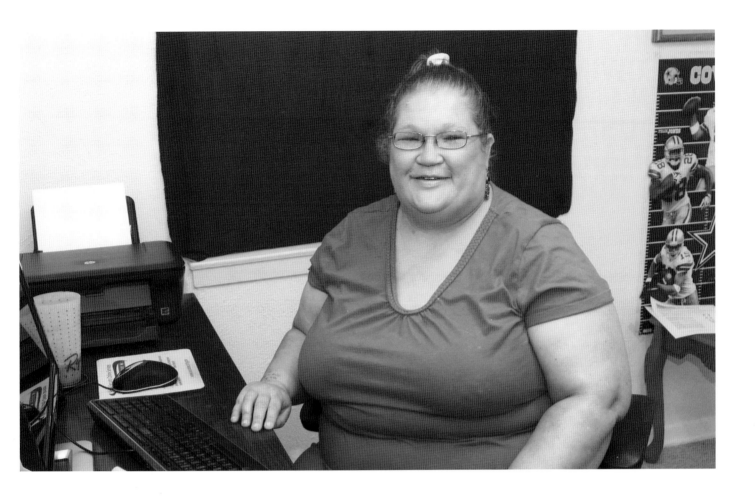

ABOVE // Anna is working at her home computer in her apartment, which she maintains impeccably and with great gratitude. Fighting to survive while living in the woods, she received word of her housing just in the knick of time. Her hope was exhausted, and she was even contemplating taking her own life.

RIGHT // Buford's favorite thing about having a home is being able to cook what he likes and eat when he is hungry.

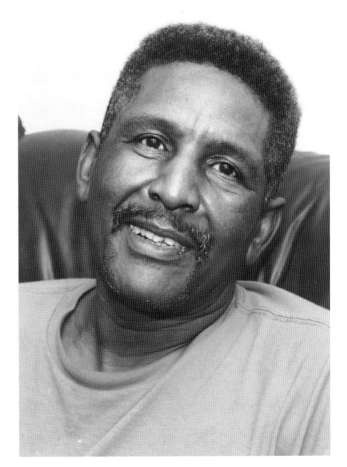

THE REST OF THIS DAY AND THE FOLLOWING TWO DAYS WOULD BE AN EMOTIONAL ROLLER COASTER, BECAUSE A PERSON WITH A FAMILIAR FACE STOOD BEHIND EACH DOOR THAT OPENED.

I listened to all the stories of how they made it out. Several were stories of how caring their case managers were or stories about the agencies that provided a safe place to stay and programs to help them avoid the pitfalls that led them to homelessness in the first place. Some proudly hung up the certificates from all the courses they had taken to get off the streets and into a home.

OPPOSITE // **Bill, formerly known as "Wild Bill," (pictured at right) still has an incredible sense of humor, but almost everything else about his life has changed since he is no longer living on the streets. Bill is now clean and sober, living a productive life in his home. He holds almost a dozen certificates recognizing his accomplishments in completing numerous courses, from life skills to computer competency.**

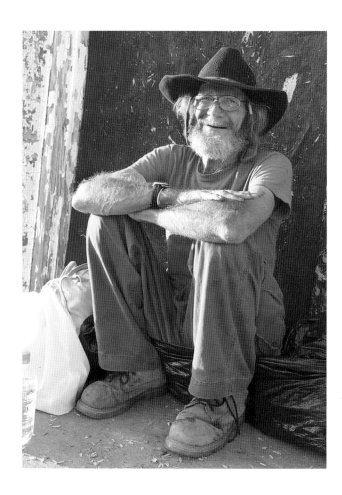

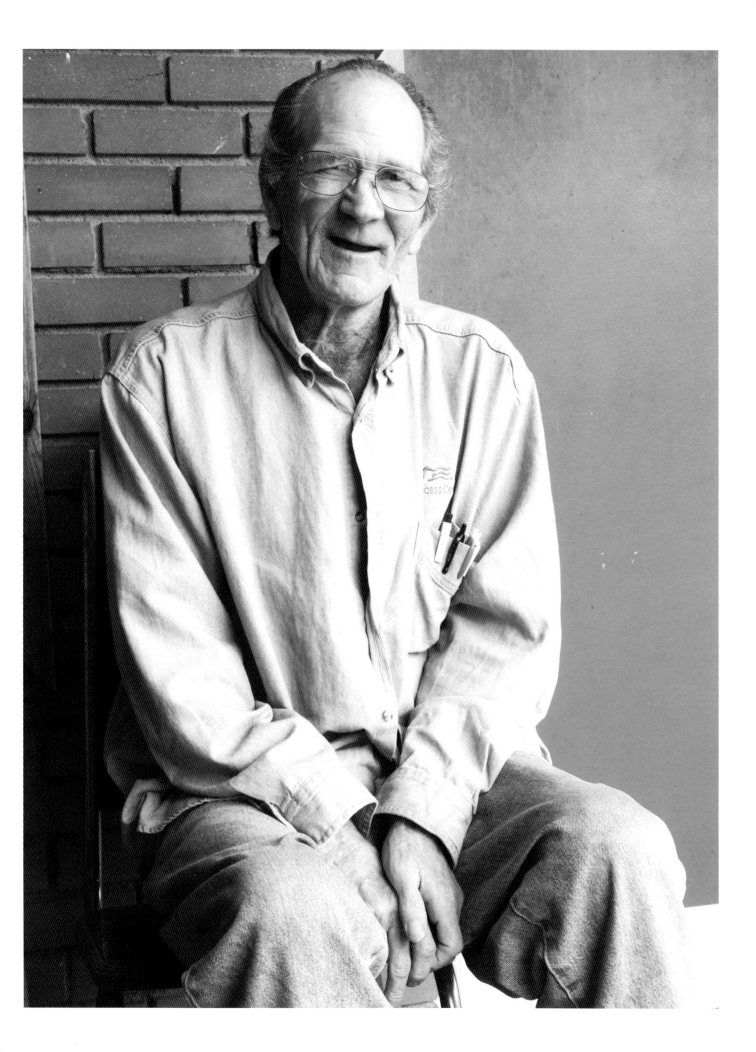

THEY ALL WANTED TO SHOW ME THE BELONGINGS THEY HAD BEGUN TO COLLECT. A FEW TOLD ME THAT NO LONGER LIVING OUT OF A PLASTIC BAG, CARRYING EVERYTHING YOU OWN WITH YOU AT ALL TIMES, FELT STRANGE AT FIRST—AND THAT AS SOON AS THEY WOKE UP THEY FELT LIKE THEY NEEDED TO PACK UP.

I visited home after home, and there was not one that wasn't taken care of properly; pride filled every room. Everyone I spoke with had a profound sense of gratitude for this second chance. They were humble, respectful, and some were still in disbelief that they survived at all.

One of the last doors I knocked on was the home of Brenda and Michael, the couple who lived in the woods for more than ten years. Their address was not on the original list, and it was only by a twist of fate that I found out they were housed. Two days prior, when they attended opening night of the photography exhibit, I rediscovered a couple I had photographed two years ago. As we visited they told me that one of their favorite photos was of their friends Brenda and Michael. I im-mediately asked a million questions about Brenda and Michael and found out that they were also in the housing program, and I knew that I had to find them. This couple did not have an address or a phone number for them, so I knew it would not be an easy search. After I left their house I called Cindy, who was as excited as I was, to see if she could find an address. It took two days of digging and numerous phone calls to various agencies to find out that the Veteran's Assistance Program had come through to help Michael get into housing. I had been given an apartment number, the name of the complex, and an address, but still no phone information.

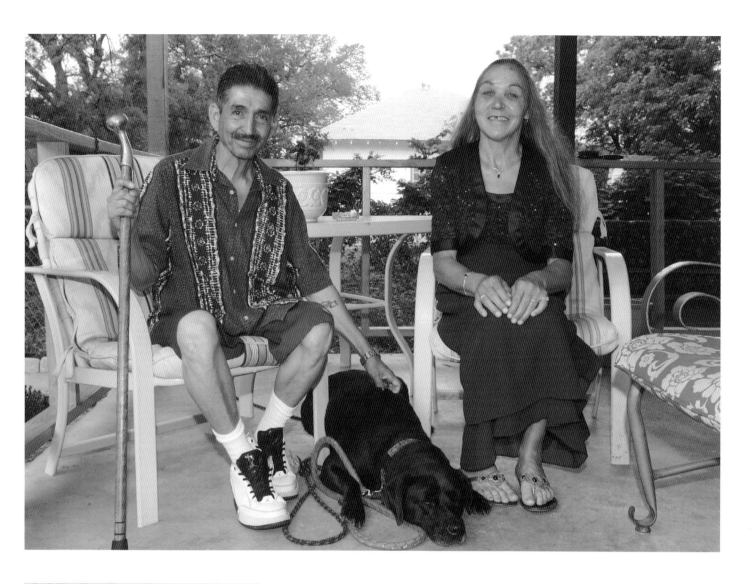

ABOVE // **Polite, kind, generous, and extremely grateful are adjectives that would best describe Richard and Renee, pictured here, sitting on their front porch with their big black lab. They spent more than a decade living in wooded encampments or squatting in abandoned or condemned houses.**

RIGHT // **Marion found herself homeless after the sudden and tragic death of her husband, the sole provider for the household. With the help of *Directions Home*, she now has a safe place to live, grieve, and learn how to live alone, providing for herself.**

I jumped on the computer, printed off a map, and was on my way. When I arrived at the address it was an empty lot. Just the sight of it left me numb in disbelief. Determined, I drove around the neighborhood for quite a while before I stopped at a convenience store to ask if anyone knew of the apartments. There were several people around the counter, all of whom gave me a look that let me know I did not belong there, and not one offered to help. I went back to my truck and sat there feeling discouraged and unsure of what to do next. That was when a man tapped on my window, scaring me half to death. He was a worker for a utility company who must have overheard my conversation in the store. I got out of the truck when he said, "Let me see your map." I gave him all the information I had and prayed that he would be able to help. It turned out that he grew up on this side of town a long time ago, and he still knew his way around. He drew me a new map on a scrap of paper and saw me off with a point in the right direction. It turned out that I was only a couple of miles away.

I found the apartment complex and a door that matched the number I had been given, although I had no idea if it was accurate. With hope in my heart, and a bit of hesitation, I knocked on the door and waited. Michael opened the door and stood there, a bit puzzled. This was a cold call, after all. Hellos were exchanged, but then he saw my camera and recognized who I was. He invited me in and called out to Brenda, "Come here, we have company." Brenda emerged from another room and in an instant, smiles, hugs, and laughter filled the room. It was a moment unlike any other; it was as if we were long lost friends or relatives reuniting after a long absence. This reunion was incredibly special to me because these two people, their story, and their prior living conditions had haunted me since the day we met. They gave me the grand tour and showed me all the special little knick-knacks everywhere. Their apartment, unlike most of the others, was full of furniture and the smell of a pot roast simmering on the stove filled the air. They both kept saying over and over how blessed

they were to be in a home and to have all these wonderful things that they now had. We talked and laughed together for a long time. Later, I photographed both of them individually and then went to set up a shot of them together. Brenda suggested the fireplace, and I agreed.

I had taken several photos when I noticed the word JOY carved in wood hanging on the mantel at their shoulders. I stopped to point out the sign and told them that the first time I took their picture they had the word HOPE hanging from their cart. We all laughed and agreed that with a great deal of hope in your life joy can become a part of it too. When the time came to leave, they both walked me to my truck. We exchanged long hugs and joked about meeting again and how fate had brought everything around full circle.

DRIVING AWAY WAS HARD, BUT I LEFT INVIGORATED, KNOWING THE SYSTEM CAN AND DOES WORK TO HELP THOSE IN NEED.

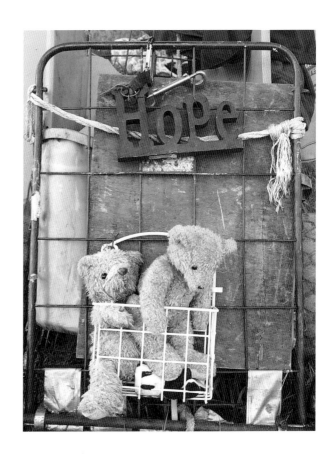

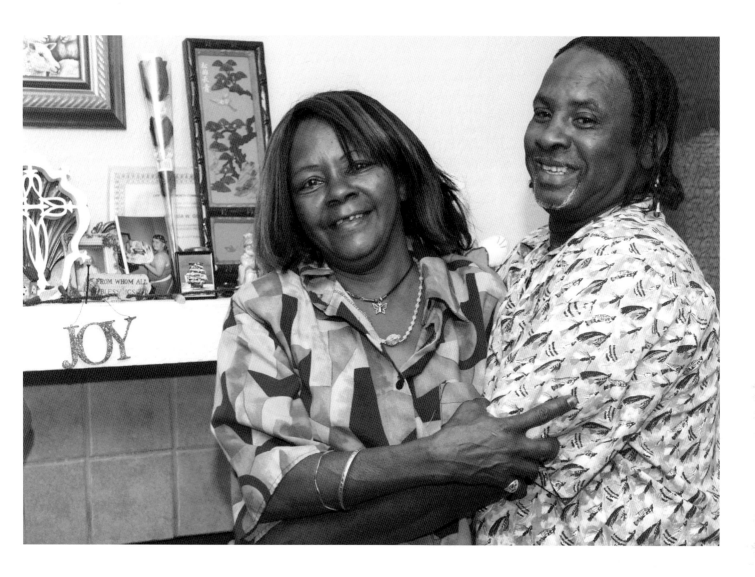

ABOVE // **Brenda and Michael endured more than ten years of moving from one camp to another, pushing a cart with the word *Hope* wired to the front. Now they stand in their home by their fireplace, which is adorned with the word *Joy*.**

RIGHT // **Brenda fills the air of her home with the aroma of a pot roast simmering in the oven, all the while telling me how blessed she is that so many people cared and helped her rebuild her life.**

Meeting all those courageous people who were whole again helped me feel energized and more hopeful than ever before. I saw undeniable results that people can change if given the opportunity, and that a hand up can help them find the strength and self-worth to rebuild their shattered lives. After the first assignment, I had vowed never to stop trying to make a difference in the lives of the poverty-stricken and homeless, but it is hard not to get discouraged or feel overwhelmed at times. One winter, for instance, a severe ice storm had knocked out the power at the Presbyterian Night Shelter. We had over 700 clients to serve with no way to cook and no running water. Thanks to social media, however, word got out that supplies were very low. Volunteers willing to brave the ice-slick roads turned out to deliver supplies. I filled my truck up three times with food and water donated by local businesses that were open.

IT WAS A GREAT FEELING UNLOADING ALL THOSE GIFTS FROM HEAVEN THAT DAY; WE ALL HUGGED AND THANKED EVERYONE WHO CAME TO THE RESCUE.

RIGHT // **Sandra is very happy to finally be safe from the dangers of living on the streets. No longer living out of a plastic trash sack, she enjoys collecting small objects and decorating her living area, making it home.**

RIGHT // **Tommy, having burned every bridge with family and friends while struggling with addiction, was dropped off on the street outside the homeless shelter. It took a while, but he finally entered a residential treatment and recovery center run by MHMR. He was placed in supportive housing and found part-time work. Today he works full-time and is no longer on any public assistance.**

We all drove slowly home on the treacherous roads that night, feeling pretty good about our community's willingness to help. Only a few blocks away, however, I realized that everything we'd brought in would only last a day, maybe a day and a half. It is times like these that you begin to understand the vastness of the problem and how much help is needed. The numbers of homeless are staggering, and I firmly believe that the only way to get a handle on the situation is to prevent people from falling into homelessness in the first place.

As a caring community, we must continue to support those in need. There are so many established, non-profit agencies working diligently through proven programs that are helping people get back up on their feet again, and most depend on public and private funding to survive. I believe we can all do something to help. It doesn't need to be a big thing; sometimes the smallest thing can matter the most. Some people give monetary donations and some like to volunteer, while others may be able to use their professional training to aid an organization.

THE LOOK IN THEIR EYES AND THE HAPPINESS ON THEIR FACES THAT I WITNESSED WHILE PHOTOGRAPHING THE FORMERLY HOMELESS WERE PROOF ENOUGH FOR ME THAT THE FIGHT MUST CONTINUE.

ABOVE // Monte was chronically homeless before he was helped with supportive housing. Today, he thrives as an artist, working from a small studio in his home. Monte volunteers once a week, counseling men and women at the Presbyterian Night Shelter.

RIGHT // Mark is a prime example of how many Americans could find themselves homeless virtually overnight. He was a hard-working man and business owner who fell ill. The prognosis: a degenerative brain disease with no cure. Mark wandered the streets for years before he found help obtaining and filing the proper documents for him to receive the social security and disability benefits he had earned.

If you are reading this book, then you are probably someone who cares. Can one person make a huge difference? The answer is yes. If you care, others will care, and the ripples in the pond will begin. I ask you to think about what part you can play in changing someone's life for the better. If you choose to look at the big picture, it may seem impossible to make even a slight difference, but if you focus your efforts on someone or some organization close to you, change will happen, and you will begin to see the world through new eyes.

CARING IS CONTAGIOUS. BE THE ONE TO START AN EPIDEMIC.

OPPOSITE // Debra bounced around from town to town, shelter to shelter, and camp to camp, before being housed. She is so grateful to have a safe, clean home—one with running water, electricity, and a recliner. Now that Debra has stability in her life, she seeks to find fulltime employment and has hopes of regaining custody of her daughter.

HOMELESSNESS IS A HARSH, FRIGHTENING, HUMILIATING CONDITION THAT MOST OF US WOULD RATHER NOT THINK ABOUT TOO MUCH.

We tend to think it is something that happens to "other people"—either as the result of bad behavior or horrific, odds-defying bad luck. It won't (can't) happen to us. That's what we want to believe.

It would be more disquieting to acknowledge the hard truth: that homelessness can befall almost anyone, even in Fort Worth. The truth is that many of us, including some of your friends, family members, coworkers, and neighbors, are only one missed paycheck, one serious illness, or one family crisis away from being homeless. Our fellow citizens living with physical or mental disabilities and those suffering from chemical dependencies are particularly at risk for homelessness. People are often surprised to learn that more than twenty-five percent of our homeless population are children, and another significant portion of that population is composed of military veterans.

B.J. Lacasse has done the Fort Worth community a tremendous service with the publication of this remarkable book, *The Street*. Her incredible photographs succeed in putting a human face on homelessness. They are glimpses into the souls of the homeless living in our own backyard—and they demand not just our empathy, but our action. B.J.'s skills as a photojournalist and an artist help us understand the problem and provoke us into doing something about it.

Which brings me to my favorite aspect of *The Street*, which is its hopefulness. When I look at "The Return: Two Years Later" section of *The Street*, I am moved by the smiling faces of the formerly homeless who have bravely turned their lives around. This is the evidence that there is good reason for hope. Fort Worth has adopted a sound ten-year plan for ending homelessness in our city. All indications are that the plan is working. The number of homeless people in Fort Worth is declining. Strategies for helping people secure permanent housing, jobs, and supportive services are succeeding.

Just as there are many causes of homelessness, there are many players who have a role in solving it. Government, at all levels, is part of the solution. The non-profit sector, especially the faith community, plays a critical role. In that respect, there has been no more important institution than the Presbyterian Night Shelter, which has offered essential but largely unseen services for the past twenty-five years. The private sector, through the financial support of homeless services and through providing job opportunities, has been and should continue to be a part of the overall solution. All of us working together can end chronic homelessness in Fort Worth. We should accept nothing less.

Creating *The Street* was B.J. Lacasse's response to an urgent calling. Bless her for extending that call to every one of us.

WENDY R. DAVIS
State Senator—District 10